MW00812257

THE
BOOK
OF
WILD
FLOWERS

THE
BOOK
OF
WILD
FLOWERS

Color Plates of 250 Wild Flowers and Grasses

THE NATIONAL GEOGRAPHIC SOCIETY

Plates by
Mary E. Eaton and E. J. Geske

DOVER PUBLICATIONS, INC.
Mineola, New York

Copyright

Copyright © 2020 by Dover Publications, Inc.
All rights reserved.

Bibliographical Note

This Dover edition, first published in 2020, reproduces all of the 120 color plates by Mary E. Eaton and the 8 plates by E. J. Geske previously published in *The Book of Wild Flowers* by the National Geographic Society, Washington, D.C., in 1924. For this edition, the 8 plates on black backgrounds by E. J. Geske have been combined and printed as Plates 58 and 59.

Library of Congress Cataloging-in-Publication Data

Names: National Geographic Society (U.S.), author. | Eaton, Mary E., illustrator.
Title: The book of wild flowers: color plates of 250 wild flowers and grasses / National Geographic
 Society; plates by Mary E. Eaton and E. J. Geske.
Description: Mineola, New York: Dover Publications, Inc., 2020. | This Dover edition, first
 published in 2020, reproduces all of the 120 color plates by Mary E. Eaton and the 8 plates by
 E. J. Geske previously published in *The Book of Wild Flowers* by the National Geographic
 Society, Washington, D.C., in 1924.
Identifiers: LCCN 2019054626 | ISBN 9780486840949 (paperback)
Subjects: LCSH: Flowers—United States. | Wild flowers—United States. | Grasses—United States.
Classification: LCC QK115 .N3 2020 | DDC 582.130973—dc23
LC record available at https://lccn.loc.gov/2019054626

Manufactured in the United States by LSC Communications
84094801
www.doverpublications.com

2 4 6 8 10 9 7 5 3 1

2020

English botanical artist Mary Emily Eaton (1873–1961) contributed the 120 pages of flower paintings for the original 1924 edition of *The Book of Wild Flowers* while she was employed by The New York Botanical Garden. At the time, *National Geographic Magazine* editor William Joseph Showalter praised her as one of the greatest of living wild flower painters, stating that "she has not only painted the likeness of the flowers with the highest botanical accuracy, but she has been able also to put the very soul of the plants into her paintings."

In his Foreword to the 1924 edition, Showalter writes that Erich John Geske's (1873–1934) "eight paintings of the flowers of familiar grasses as a microscope reveals them, show how blind our eyes are to a thousand beauties of Nature, and teach us that sharp eyes find rich nuggets of interest everywhere."

This Dover edition reproduces 250 representative species of wild flowers on 122 plates.

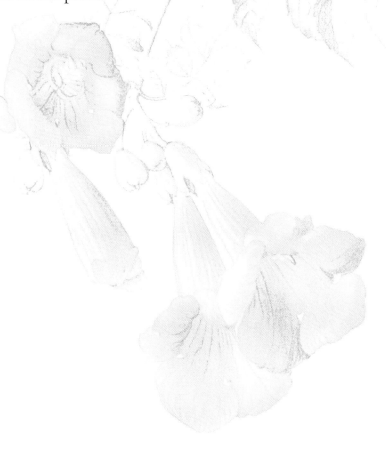

MAZZARD (Lower)
Prunus avium L.
ALMOND FAMILY

BLACK CHERRY (Upper)
Prunus serotina Ehrh.
ALMOND FAMILY

HAIRY RUELLIA
Ruellia ciliosa Pursh
ACANTHUS FAMILY

PLATE 1

AMERICAN PLUM
Prunus americana Marsh.
ALMOND FAMILY

PLATE 2

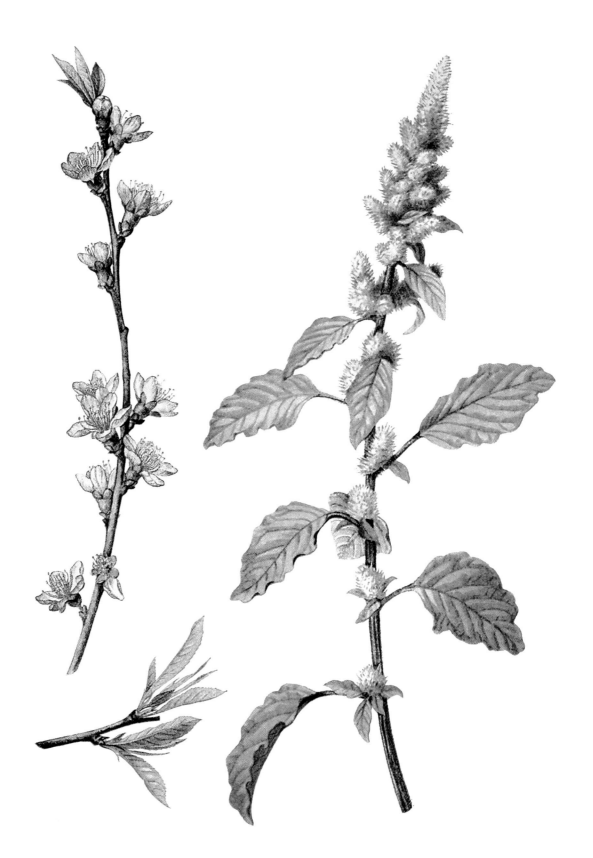

PEACH BLOSSOM
Amygdalus persica L.
ALMOND FAMILY
Delaware State Flower

COMMON AMARANTH
Amaranthus hybridus L.
AMARANTH FAMILY

PLATE 3

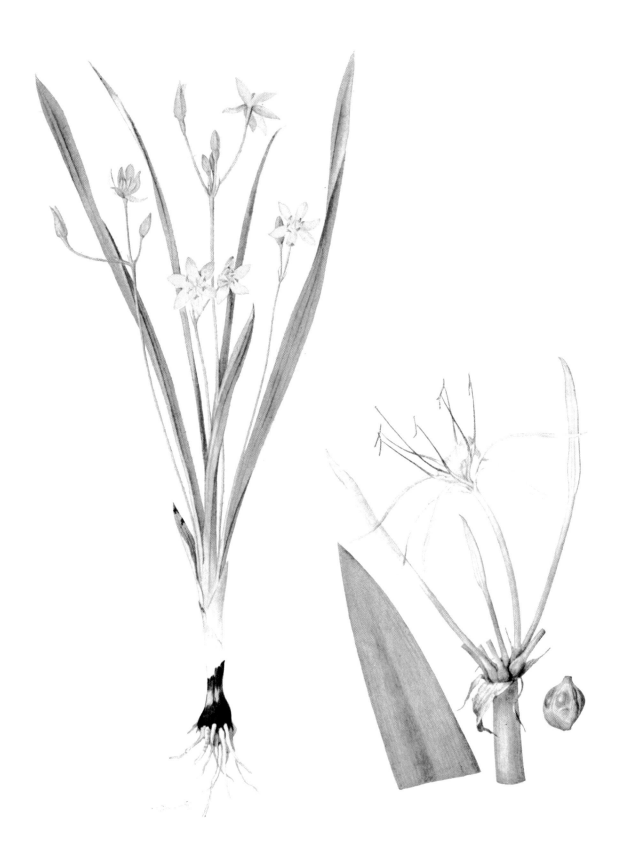

GOLDEYE-GRASS
Hypoxis hirsuta (L.) Coville
AMARYLLIS FAMILY

WESTERN SPIDERLILY
Hymenocallis occidentalis (Le Conte) Kunth
AMARYLLIS FAMILY

PLATE 4

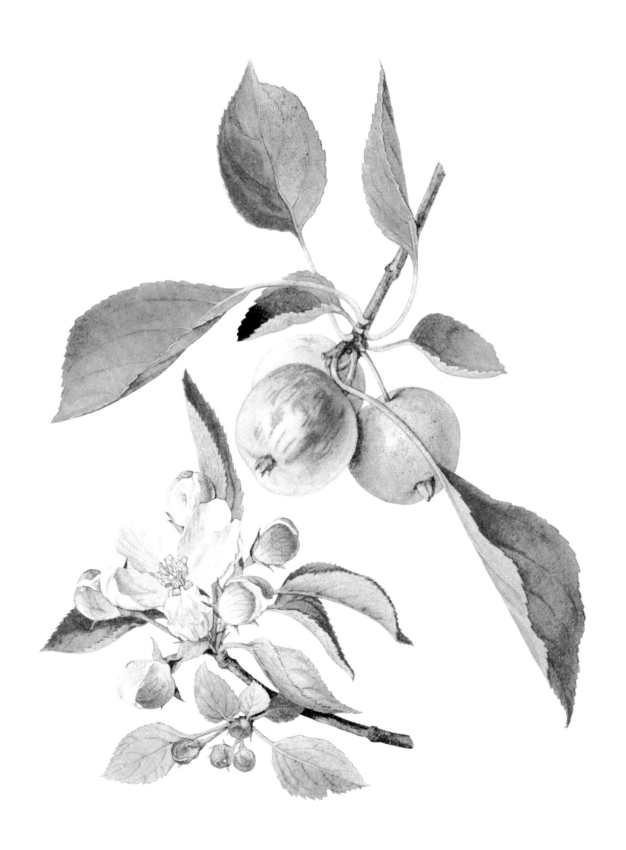

APPLE and BLOSSOM
Malus sylvestris Mill.
Apple Family
Arkansas and Michigan State Flower

PLATE 5

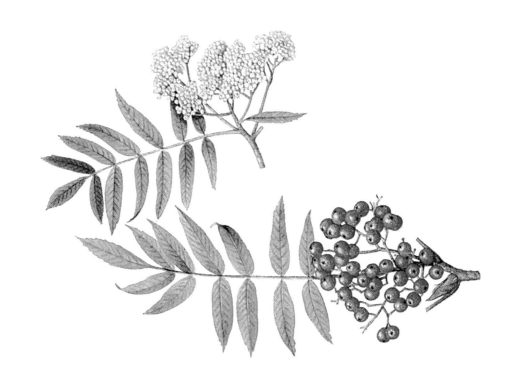

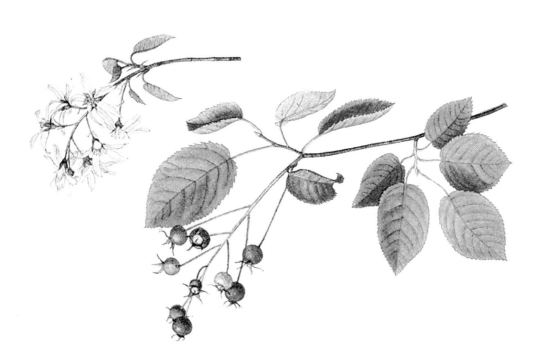

DOWNY SHADBLOW (Upper)
Amelanchier canadensis (L.) Medic.
APPLE FAMILY

AMERICAN MOUNTAIN-ASH (Lower)
Sorbus americana Marsh.
APPLE FAMILY

PLATE 6

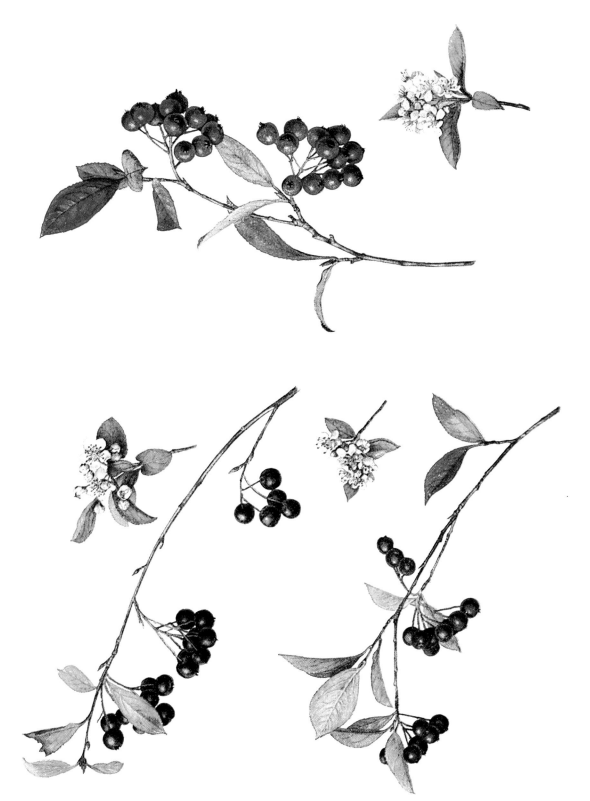

RED CHOKEBERRY
Aronia arbutifolia (L.) Ell.
APPLE FAMILY

CHOKEBERRIES
Aronia melanocarpa (Michx.) Britton (Upper)
Aronia atropurpurea Britton (Lower)
APPLE FAMILY

PLATE 7

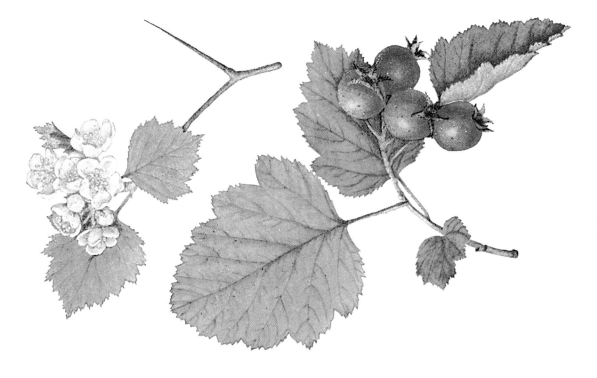

DOWNY HAWTHORN
Crataegus mollis (T. & G.) Scheele
APPLE FAMILY
Missouri State Flower

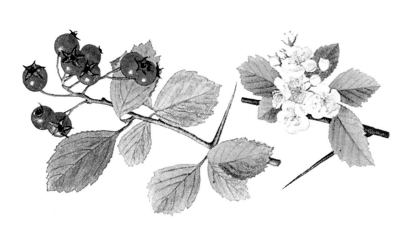

FLESHY HAWTHORN
Crataegus succulenta Schrader
APPLE FAMILY

PLATE 8

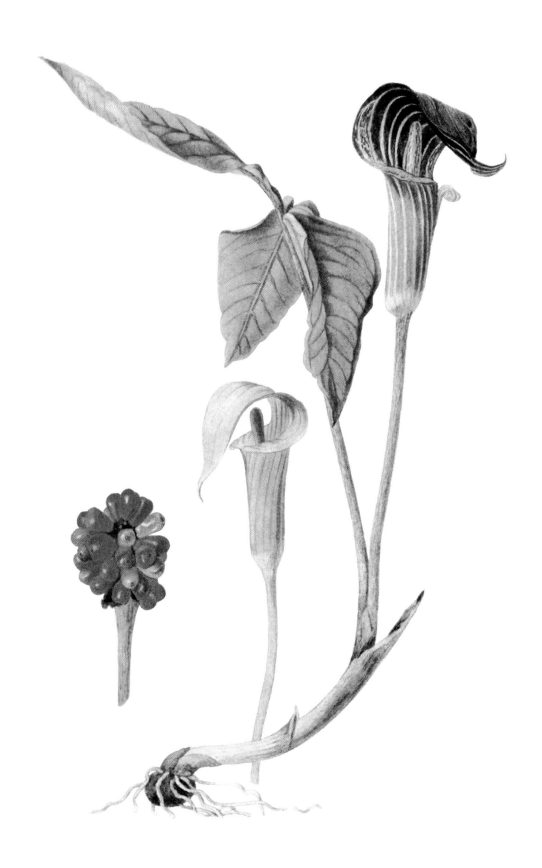

JACK-IN-THE-PULPIT
Arisaema triphyllum (L.) Torr.
ARUM FAMILY

PLATE 9

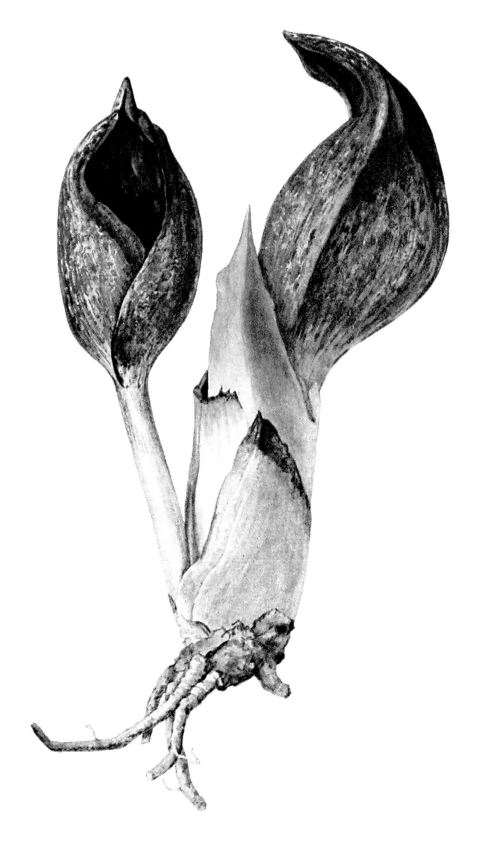

SKUNK CABBAGE
Spathyema foetida (L.) Raf.
ARUM FAMILY

PLATE 10

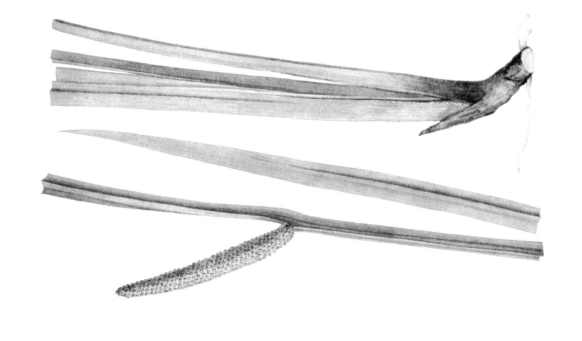

SWEETFLAG
Acorus calamus L.
ARUM FAMILY

GOLDENCLUB
Orontium aquaticum L.
ARUM FAMILY

PLATE 11

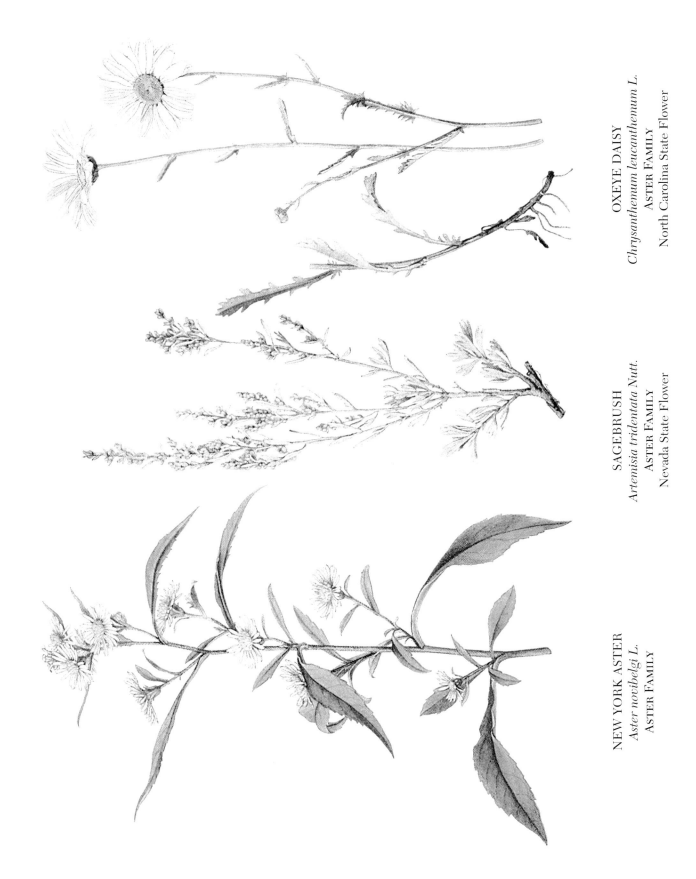

OXEYE DAISY
Chrysanthemum leucanthemum L.
ASTER FAMILY
North Carolina State Flower

SAGEBRUSH
Artemisia tridentata Nutt.
ASTER FAMILY
Nevada State Flower

NEW YORK ASTER
Aster novibelgi L.
ASTER FAMILY

PLATE 12

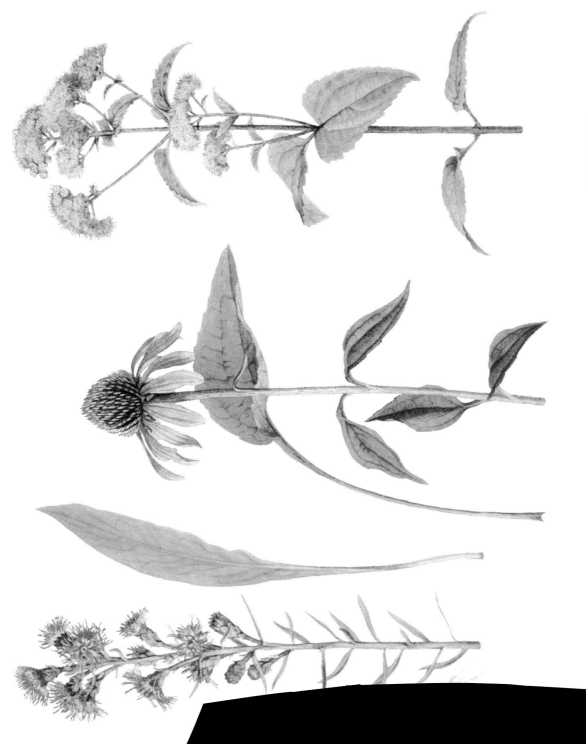

MISTFLOWER
Eupatorium coelestinum L.
ASTER FAMILY

PURPLE CONEFLOWER
Echinacea purpurea (L.) Moench
ASTER FAMILY

HER
sa (L.) Hill
ILY

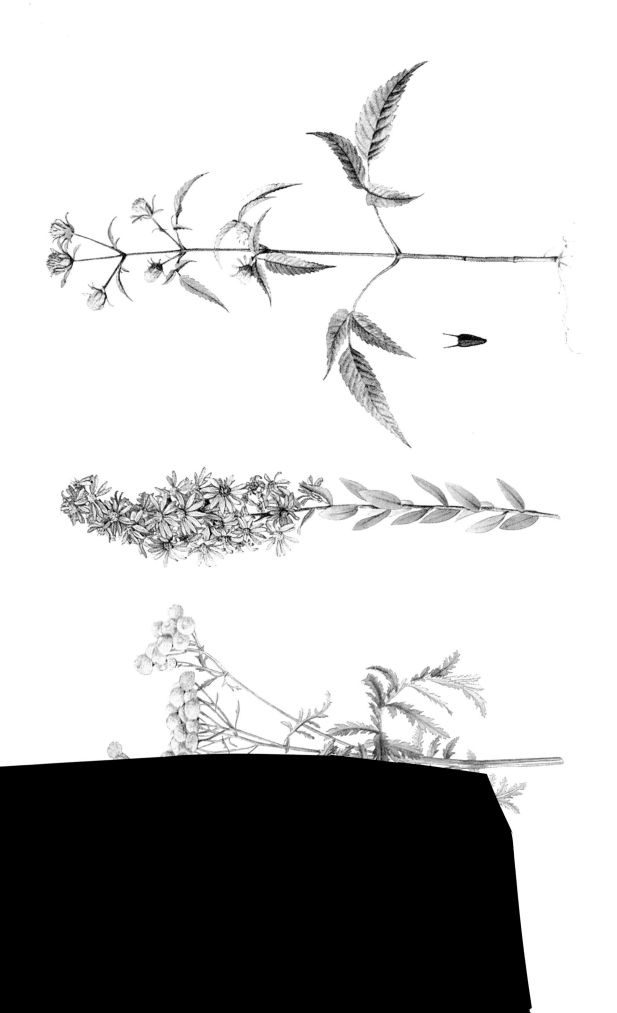

BEGGAR-TICKS
Bidens frondosa L.
ASTER FAMILY

EASTERN SILVERY ASTER
Aster concolor L.
ASTER FAMILY

COMMON TANSY
Tanacetum vulgare L.
ASTER FAMILY

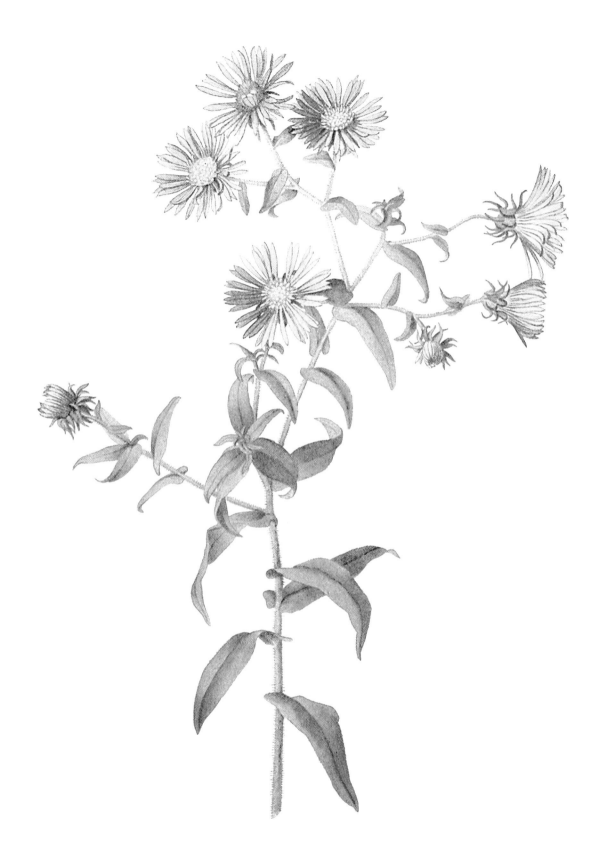

NEW ENGLAND ASTER
Aster novae-angliae L.
ASTER FAMILY

PLATE 15

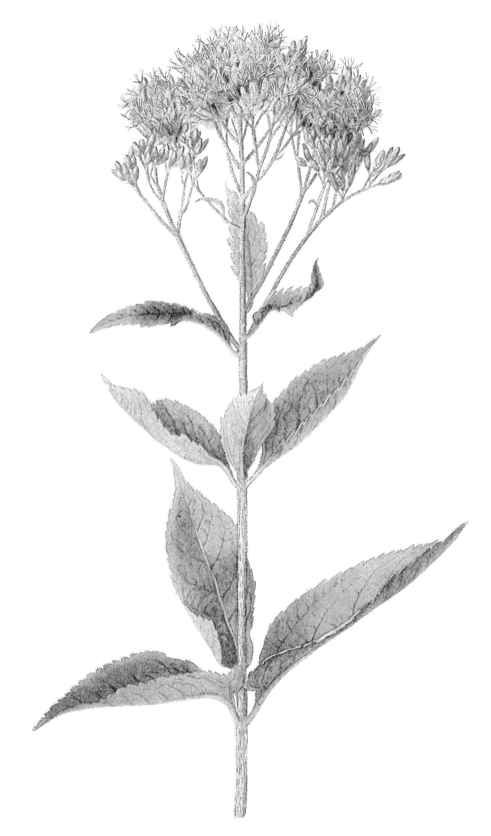

ROUGH JOE-PYE-WEED
Eupatorium maculatum L.
ASTER FAMILY

PLATE 16

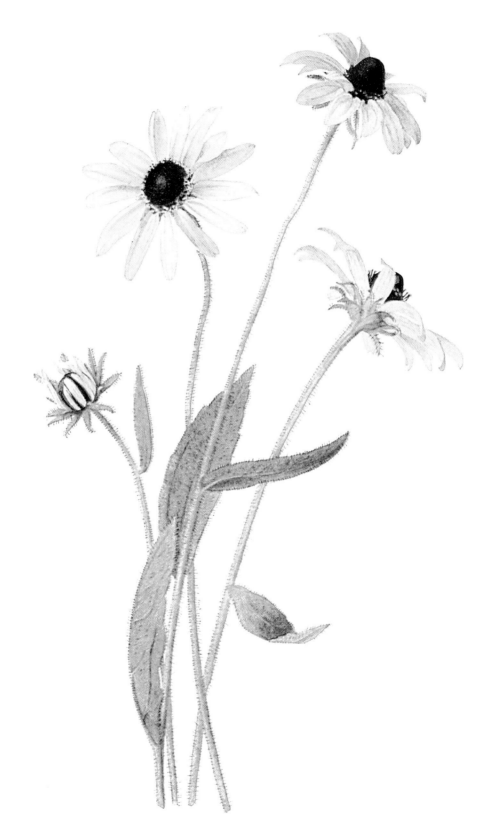

BLACK-EYED SUSAN
Rudbeckia hirta L.
ASTER FAMILY
Maryland State Flower

PLATE 17

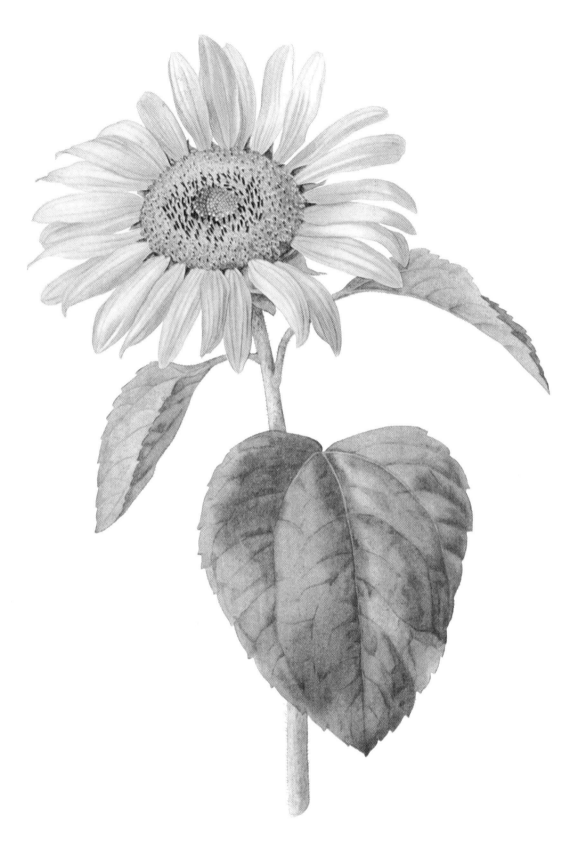

COMMON SUNFLOWER
Helianthus annuus L.
ASTER FAMILY
Kansas State Flower

PLATE 18

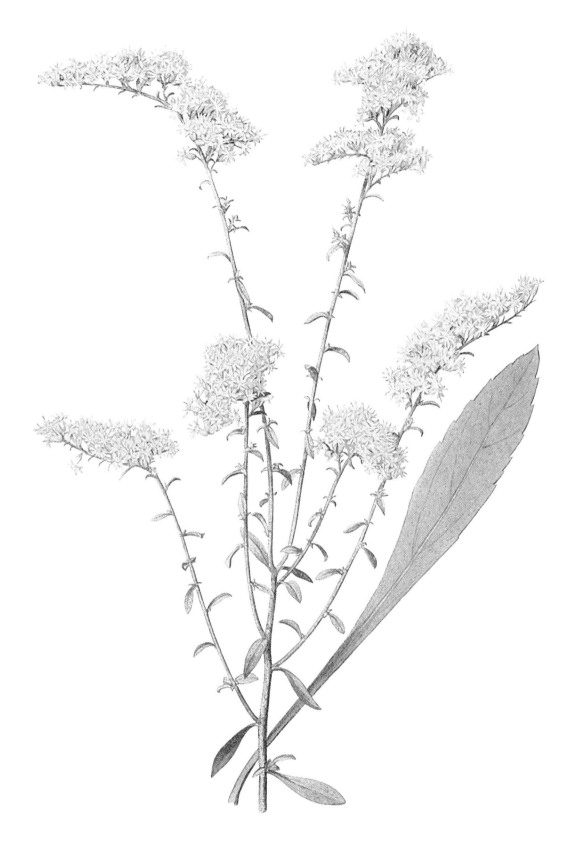

OLDFIELD GOLDENROD
Solidago nemoralis Ait.
Aster Family
Nebraska and Alabama State Flower

PLATE 19

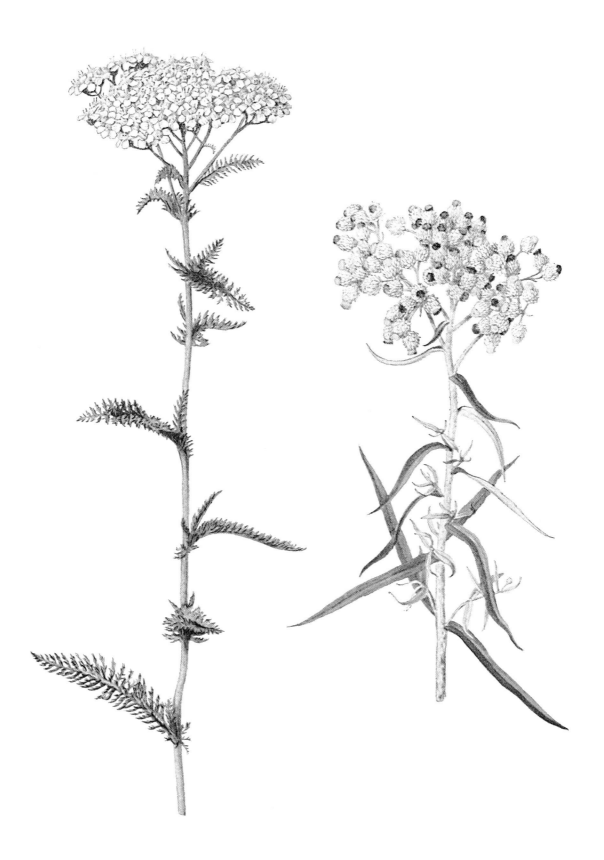

COMMON YARROW
Achillea millefolium L.
ASTER FAMILY

PEARL EVERLASTING
Anaphalis margaritacea (L.) Benth. & Hook.
ASTER FAMILY

PLATE 20

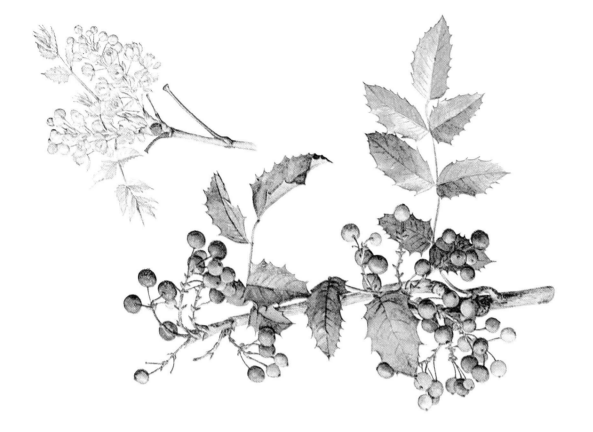

OREGON HOLLYGRAPE
Berberis aquifolium Pursh
BARBERRY FAMILY
Oregon State Flower

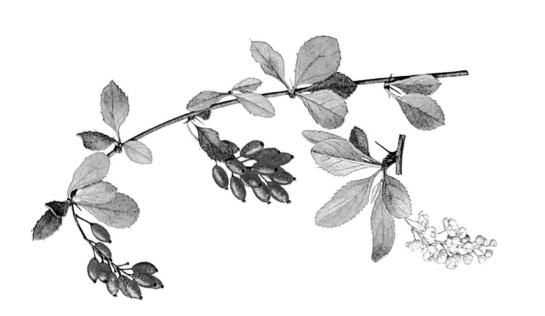

EUROPEAN BARBERRY
Berberis vulgaris L.
BARBERRY FAMILY

PLATE 21

SWEETGALE
Myrica gale L.
BAYBERRY FAMILY

NORTHERN BAYBERRY
Myrica carolinensis Mill.
BAYBERRY FAMILY

BLUE COHOSH
Caulophyllum thalictroides (*L.*) *Michx.*
BARBERRY FAMILY

PLATE 22

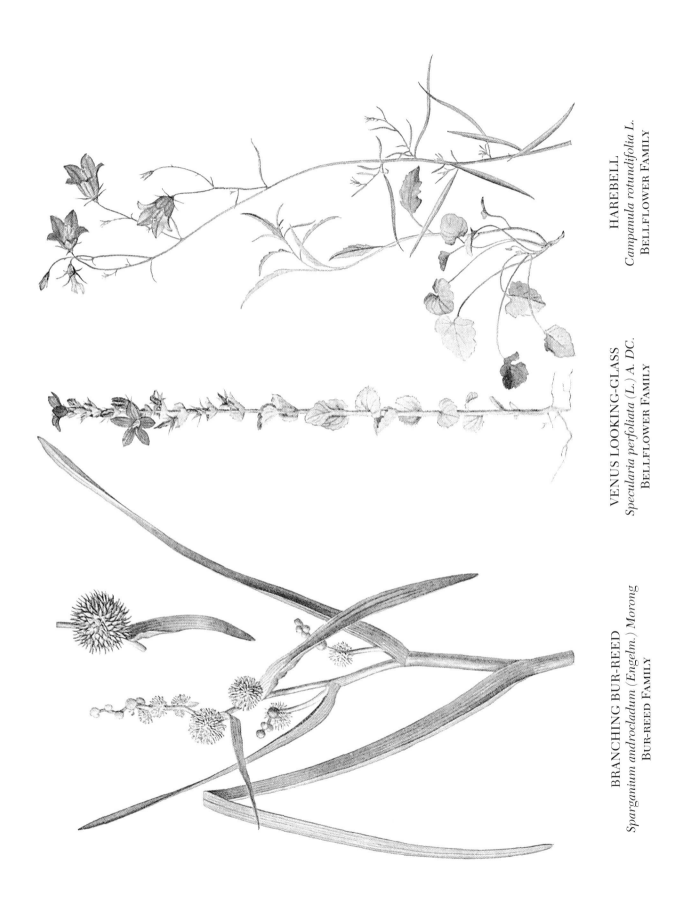

HAREBELL
Campanula rotundifolia L.
BELLFLOWER FAMILY

VENUS LOOKING-GLASS
Specularia perfoliata (L.) A. DC.
BELLFLOWER FAMILY

BRANCHING BUR-REED
Sparganium androcladum (Engelm.) Morong
BUR-REED FAMILY

PLATE 23

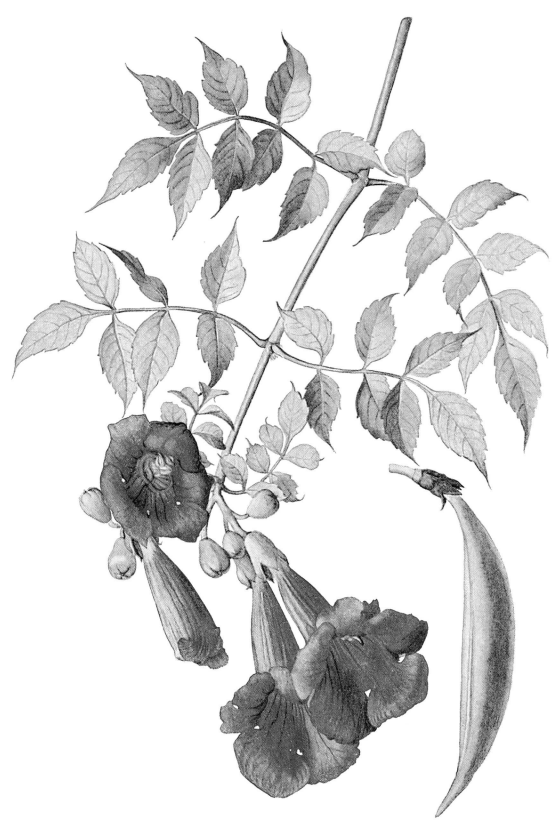

TRUMPET CREEPER
Bignonia radicans L.
Bignonia Family
Kentucky State Flower

PLATE 24

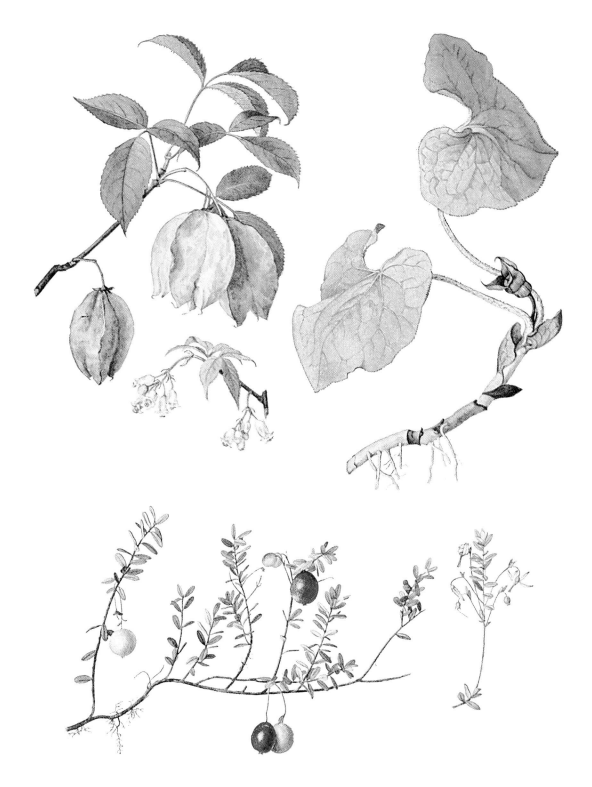

AMERICAN BLADDERNUT (Upper left)
Staphylea trifolia L.
BLADDERNUT FAMILY

CANADA WILDGINGER (Upper right)
Asarum canadense L.
BIRTHWORT FAMILY

CRANBERRY (Lower)
Oxycoccos macrocarpus (Ait.) Pursh
BLUEBERRY FAMILY

PLATE 25

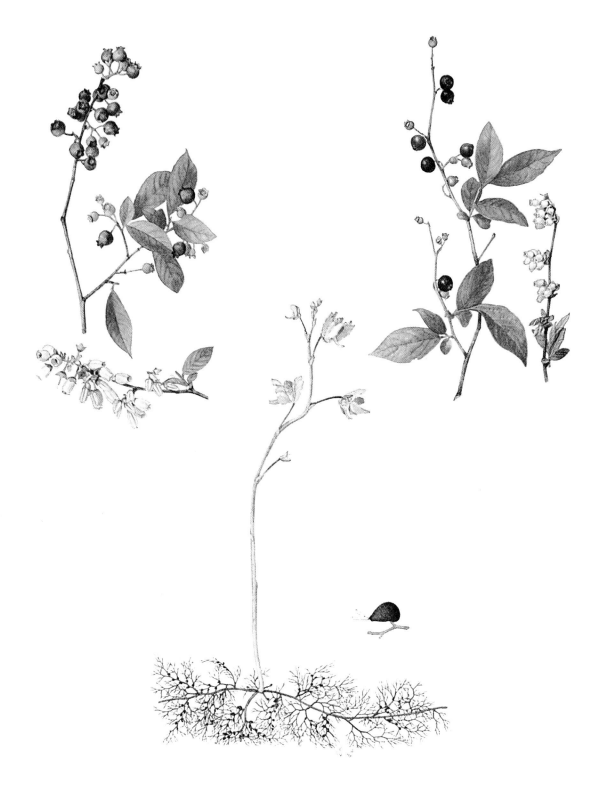

HIGHBUSH BLUEBERRY (Upper left)
Vaccinium corymbosum L.
Blueberry Family

EARLY HIGHBUSH BLUEBERRY (Upper right)
Vaccinium atrococcum (A. Gray) Heller
Blueberry Family

ZIGZAG BLADDERWORT (Lower)
Utricularia macrorhiza Le Conte
Bladderwort Family

PLATE 26

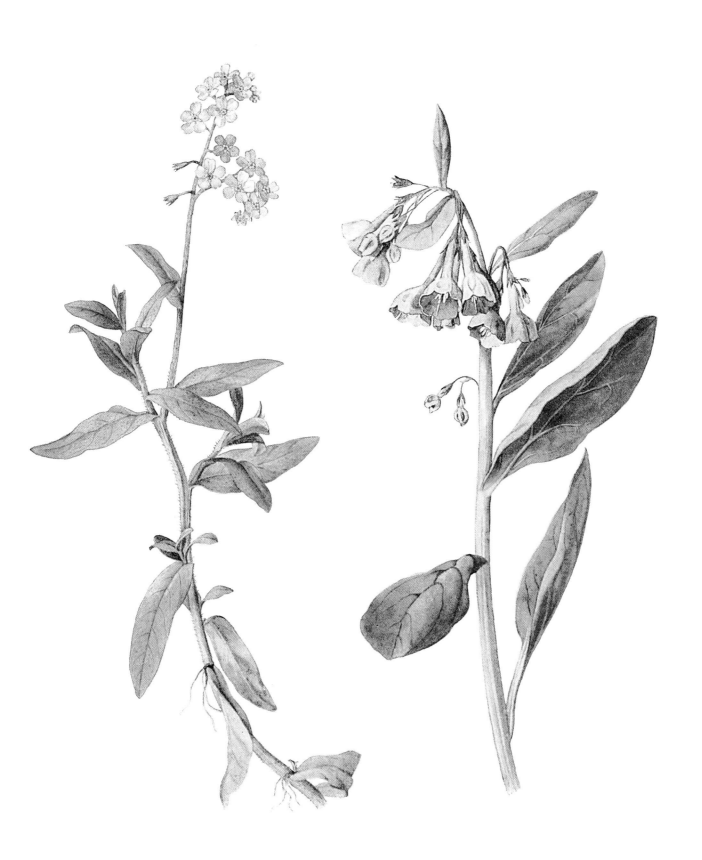

TRUE FORGET-ME-NOT
Myosotis scorpioides L.
BORAGE FAMILY

VIRGINIA BLUEBELLS
Mertensia virginica (L.) DC.
BORAGE FAMILY

PLATE 27

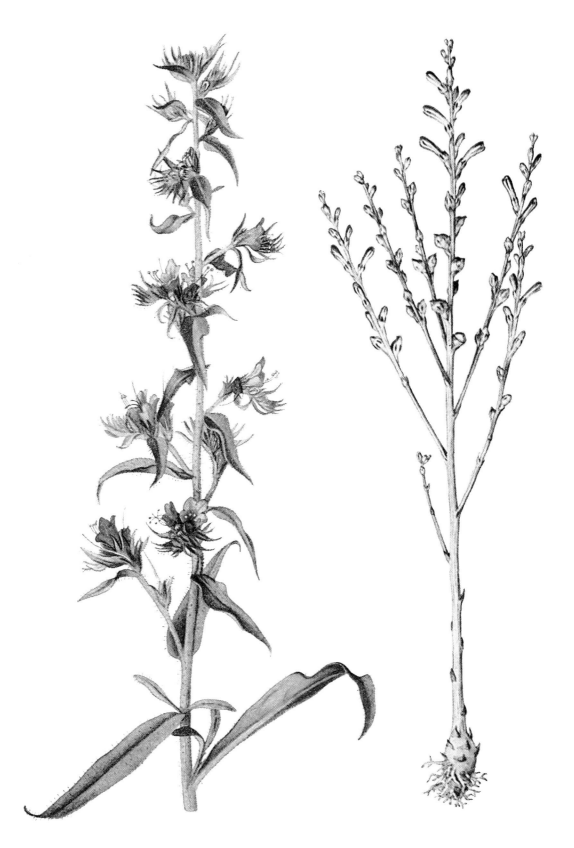

VIPERS-BUGLOSS
Echium vulgare L.
BORAGE FAMILY

BEECHDROPS
Leptamnium virginianum (L.) Raf.
BROOM-RAPE FAMILY

PLATE 28

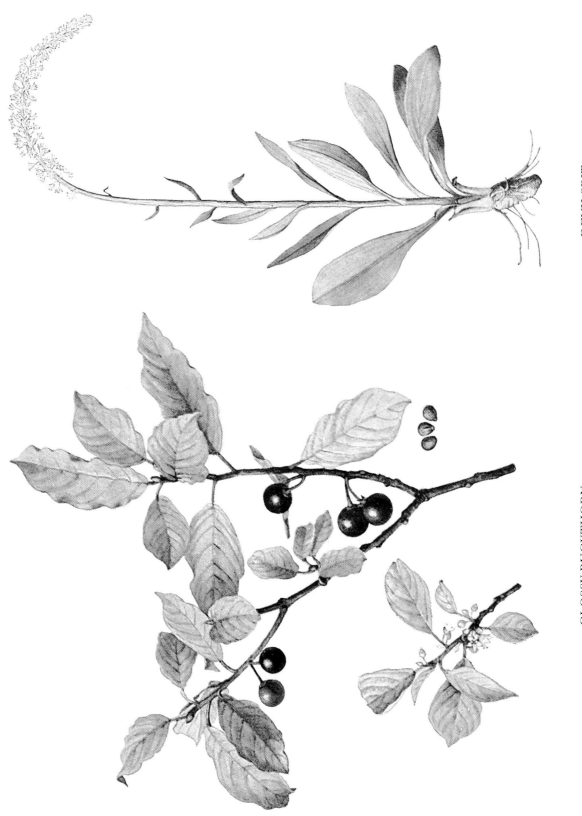

DEVILSBIT
Chamaelirium obovale Small
BUNCHFLOWER FAMILY

GLOSSY BUCKTHORN
Rhamnus frangula L.
BUCKTHORN FAMILY

PLATE 29

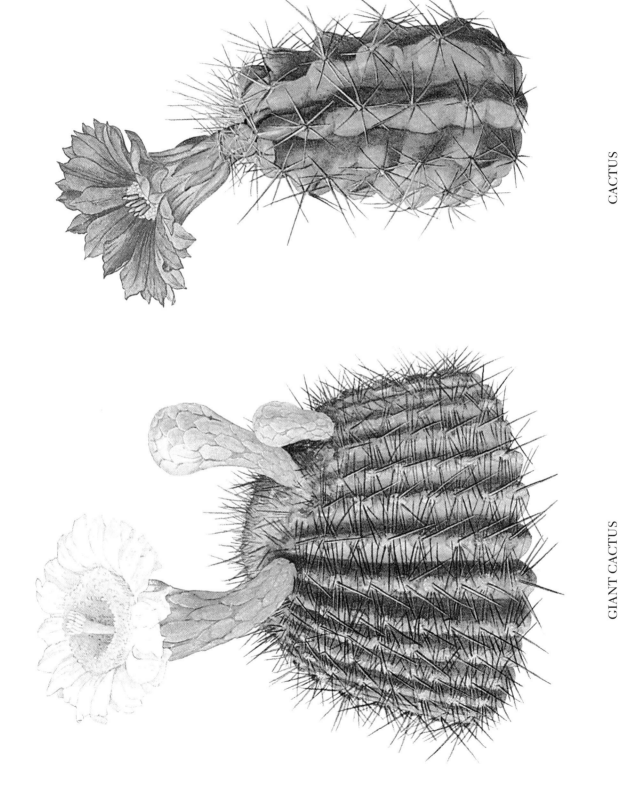

CACTUS
Echinocereus fendleri (Engelm.) Ruempl.
CACTUS FAMILY
New Mexico State Flower

GIANT CACTUS
Carnegiea gigantea (Engelm.) Britton & Rose
CACTUS FAMILY
Arizona State Flower

PLATE 30

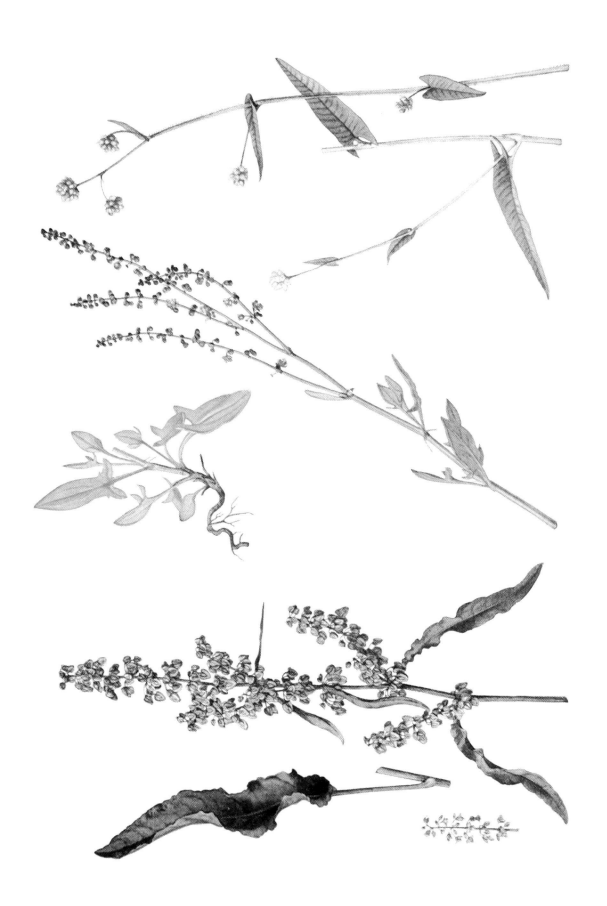

ARROWLEAF TEAR-THUMB
Tracaulon sagittatum (L.) Small
Buckwheat Family

SHEEP SORREL
Rumex acetosella L.
Buckwheat Family

CURLY DOCK
Rumex crispus L.
Buckwheat Family

PLATE 31

SPIDERFLOWER
Cleome spinosa L.
CAPER FAMILY

COMMON SWEETSHRUB
Calycanthus floridus L.
CALYCANTHUS FAMILY

PLATE 32

POISON IVY
Toxicodendron radicans (L.) Ktze.
CASHEW FAMILY

PLATE 33

SMOOTH SUMAC
Rhus glabra L.
CASHEW FAMILY

POISON SUMAC
Toxicodendron vernix (L.) Ktze.
CASHEW FAMILY

PLATE 34

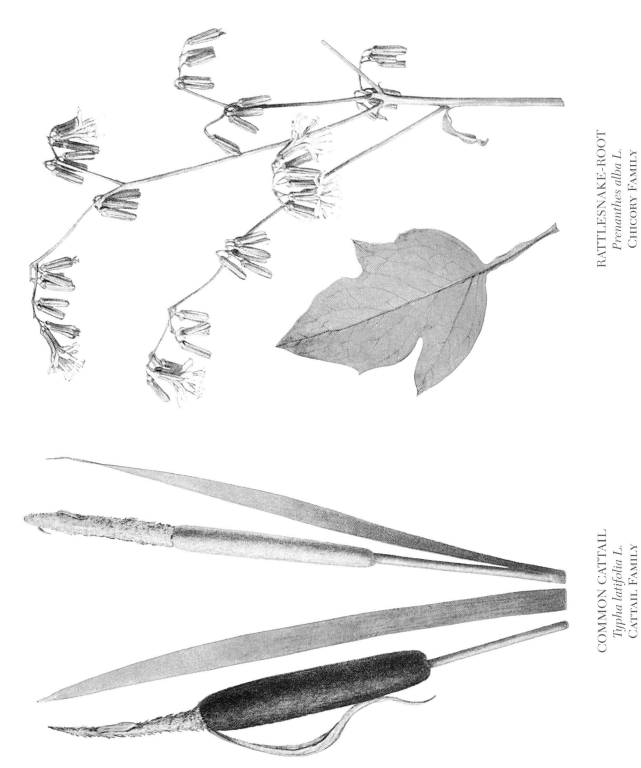

RATTLESNAKE-ROOT
Prenanthes alba L.
CHICORY FAMILY

COMMON CATTAIL
Typha latifolia L.
CATTAIL FAMILY

PLATE 35

DANDELION
Leontodon taraxacum L.
CHICORY FAMILY

ORANGE HAWKWEED
Hieracium aurantiacum L.
CHICORY FAMILY

PLATE 36

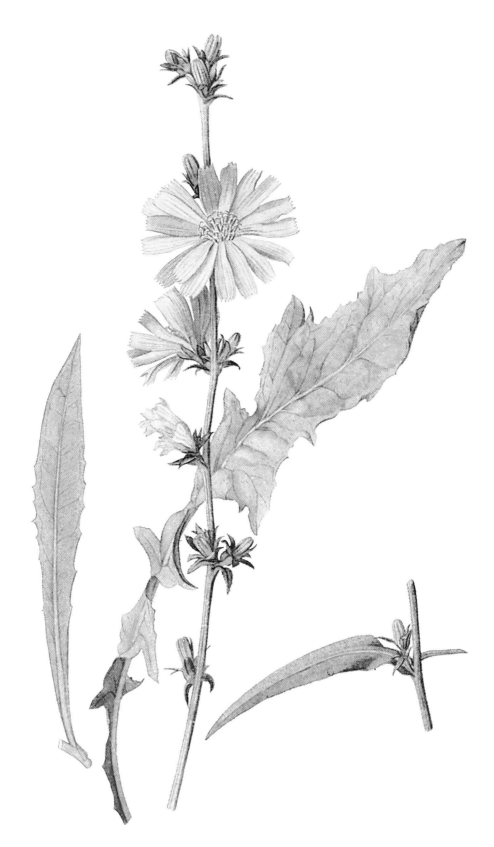

CHICORY
Cichorium intybus L.
CHICORY FAMILY

PLATE 37

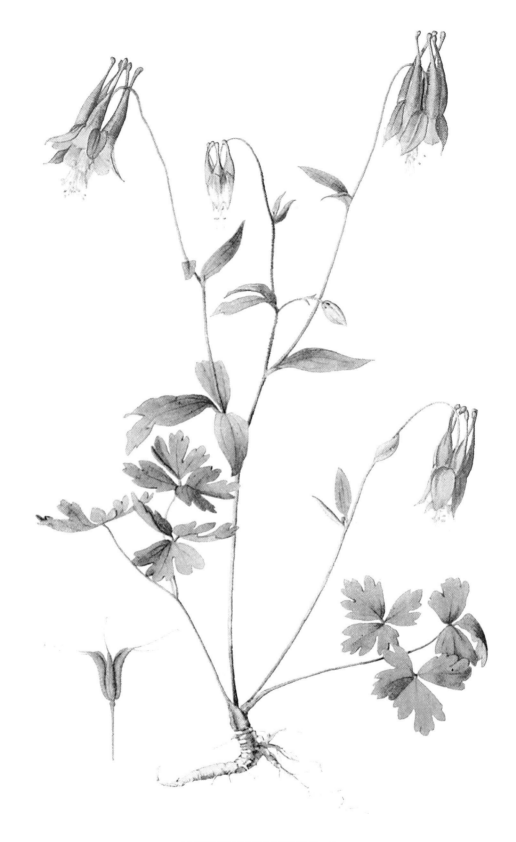

AMERICAN COLUMBINE
Aquilegia canadensis L.
CROWFOOT FAMILY

PLATE 38

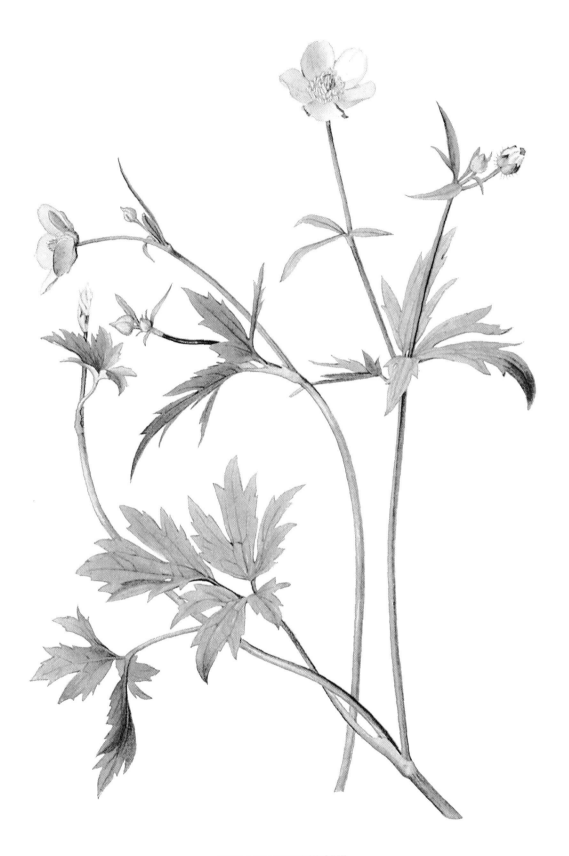

SWAMP BUTTERCUP
Ranunculus septentrionalis Poir.
CROWFOOT FAMILY

PLATE 39

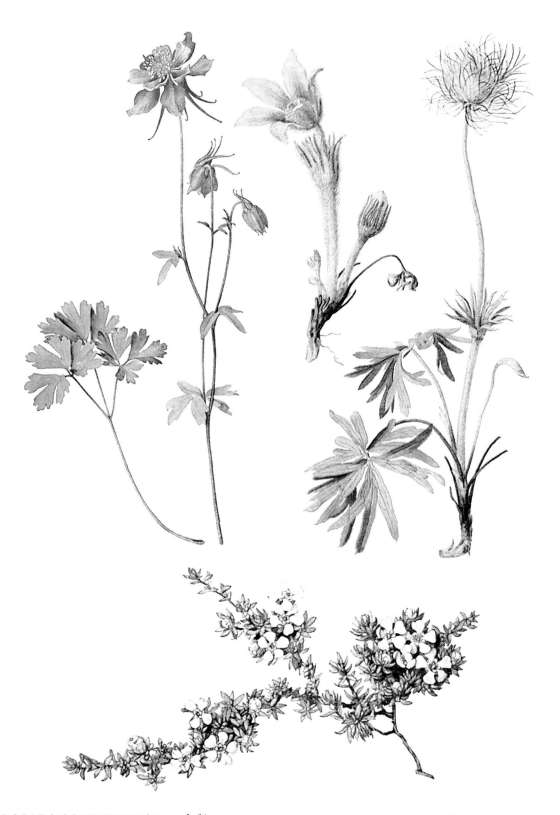

COLORADO COLUMBINE (Upper left)
Aquilegia caerulea James
Crowfoot Family
Colorado State Flower

PYXIE (Lower)
Pyxidanthera barbulata Michx.
Diapensia Family

AMERICAN PASQUEFLOWER (Upper right)
Pulsatilla ludoviciana (Nutt.) Heller
Crowfoot Family
South Dakota State Flower

PLATE 40

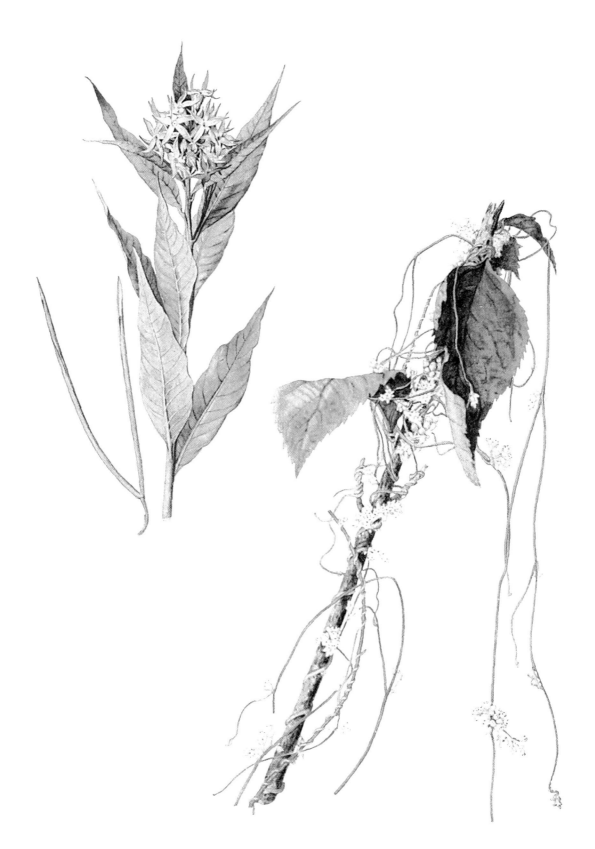

WILLOW AMSONIA
Amsonia tabernaemontana Walt.
DOGBANE FAMILY

COMMON DODDER
Cuscuta gronovi Willd.
DODDER FAMILY

PLATE 41

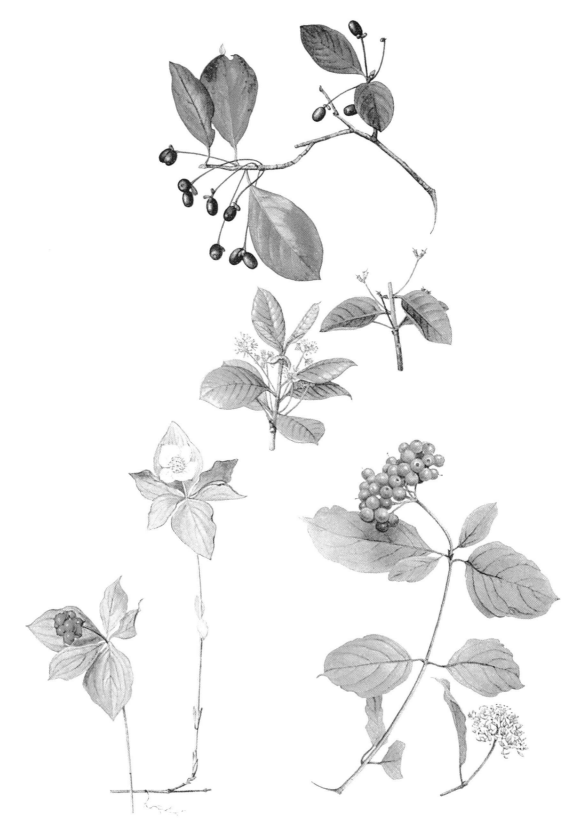

BUNCHBERRY (Lower left)
Cornus canadensis L.
DOGWOOD FAMILY

TUPELO (Upper)
Nyssa sylvatica Marsh.
DOGWOOD FAMILY

SILKY DOGWOOD (Lower right)
Cornus amomum Mill.
DOGWOOD FAMILY

PLATE 42

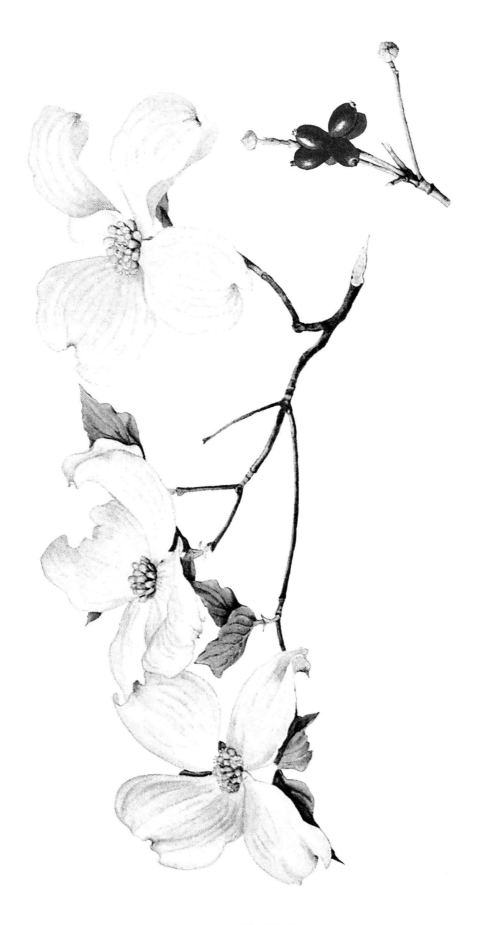

FLOWERING DOGWOOD
Cornus florida L.
DOGWOOD FAMILY
Virginia State Flower

PLATE 43

HOLMS GERARDIA
Agalinis holmiana (Greene) Pennell
FIGWORT FAMILY

COMMON SUNDROPS
Oenothera fruticosa L.
EVENING-PRIMROSE FAMILY

INDIAN PAINTBRUSH
Castilleja coccinea (L.) Spreng.
FIGWORT FAMILY

PLATE 44

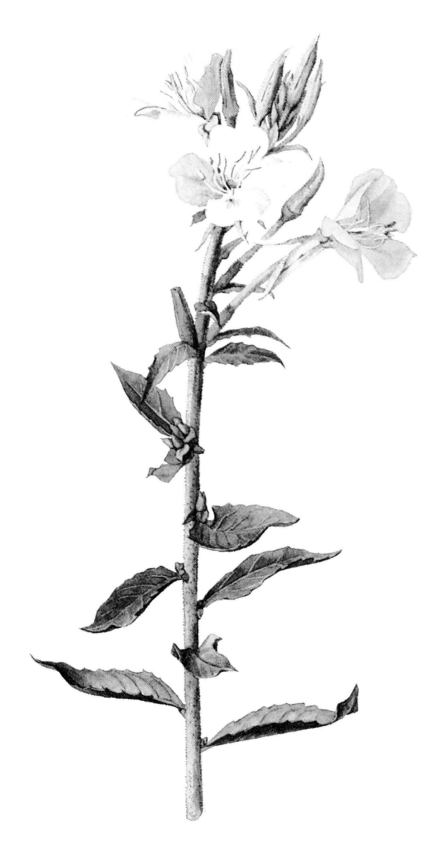

COMMON EVENING-PRIMROSE
Oenothera biennis L.
EVENING-PRIMROSE FAMILY

PLATE 45

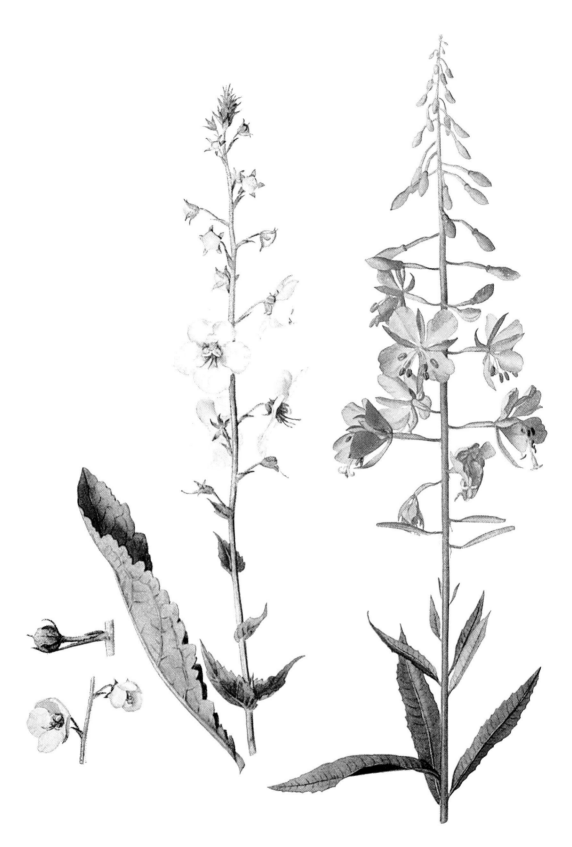

MOTH MULLEIN
Verbascum blattaria L.
Figwort Family

BLOOMING SALLY
Epilobium angustifolium (L.) Scopoli
Evening-primrose Family

PLATE 46

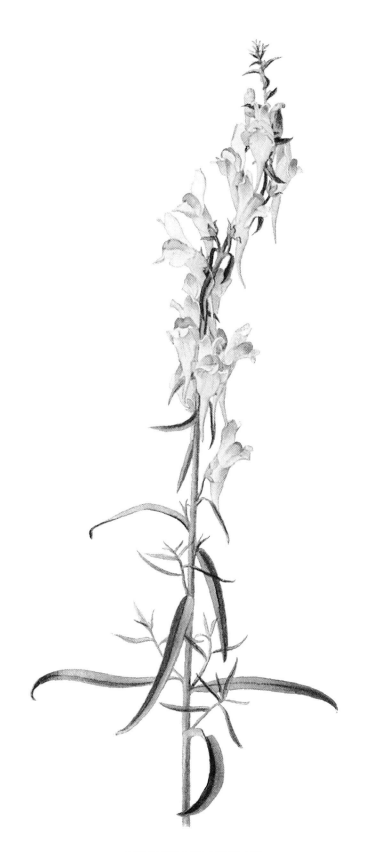

COMMON TOADFLAX
Linaria vulgaris Hill
FIGWORT FAMILY

PLATE 47

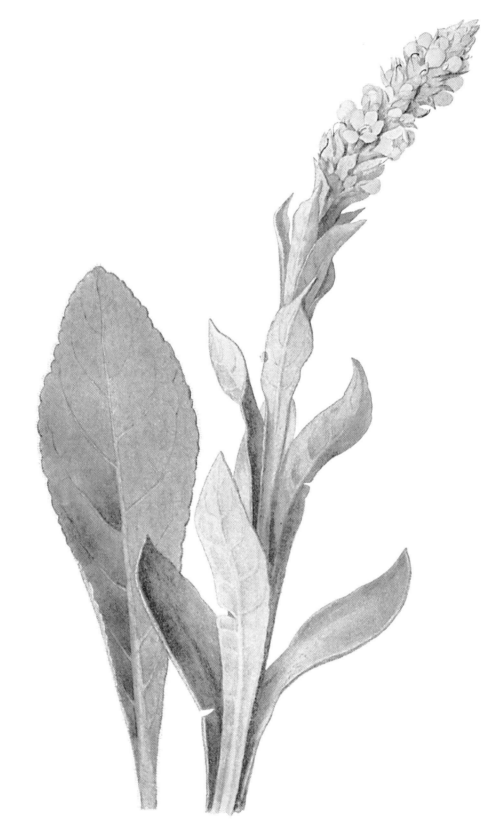

COMMON MULLEIN
Verbascum thapsus L.
Figwort Family

PLATE 48

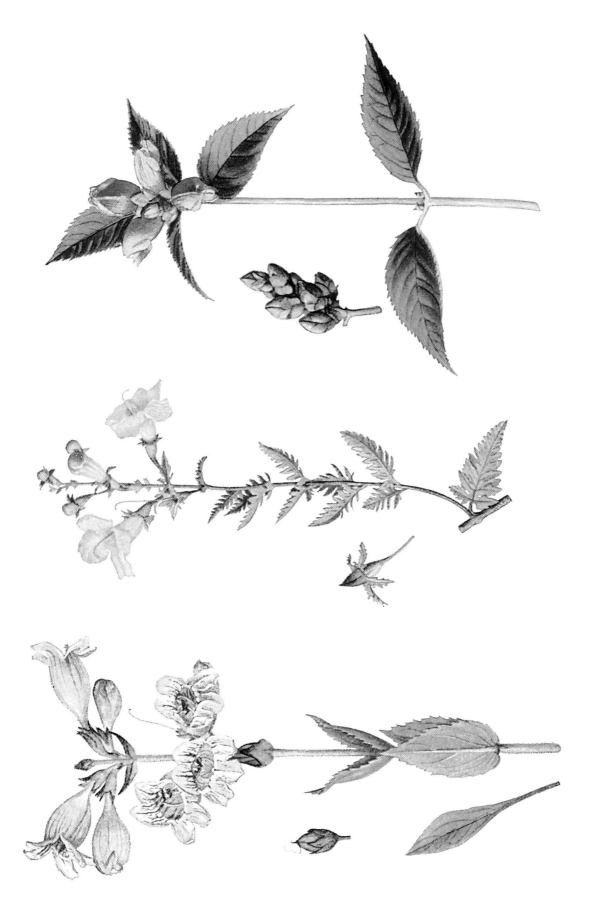

PINK TURTLEHEAD
Chelone lyoni Pursh
FIGWORT FAMILY

FERNLEAF FALSE-FOXGLOVE
Aureolaria pedicularia (L.) Raf.
FIGWORT FAMILY

COBAEA PENTSTEMON
Pentstemon cobaea Nutt.
FIGWORT FAMILY

PLATE 49

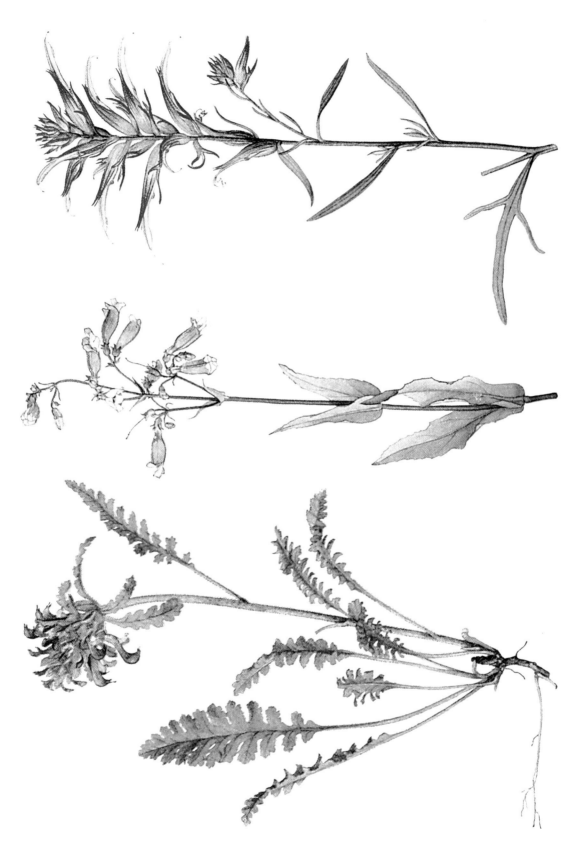

NARROWLEAF PAINTED-CUP
Castilleja linariaefolia Benth.
FIGWORT FAMILY
Wyoming State Flower

EASTERN PENSTEMON
Pentstemon hirsutus (L.) Willd.
FIGWORT FAMILY

EARLY WOODBETONY
Pedicularis canadensis L.
FIGWORT FAMILY

PLATE 50

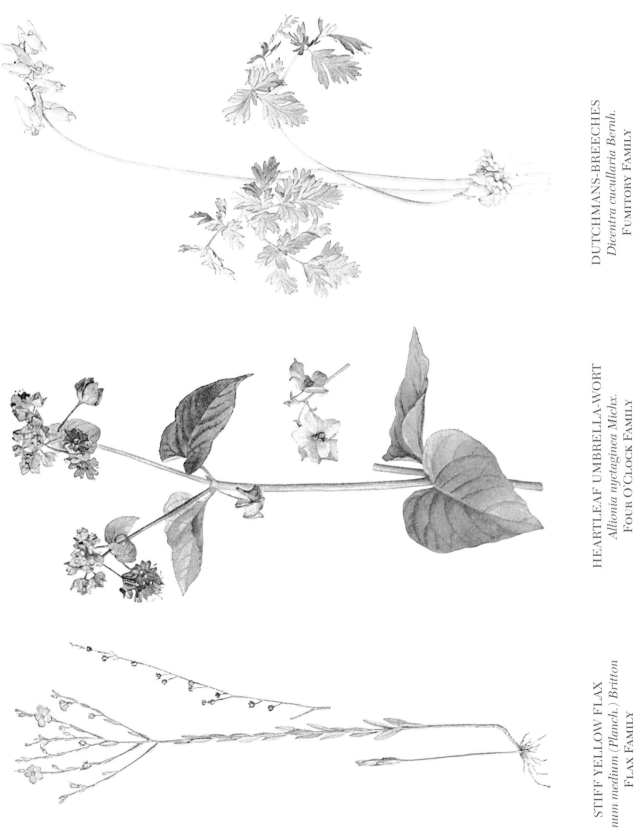

DUTCHMANS-BREECHES
Dicentra cucullaria Bernh.
FUMITORY FAMILY

HEARTLEAF UMBRELLA-WORT
Allionia nyctaginea Michx.
FOUR O'CLOCK FAMILY

STIFF YELLOW FLAX
Linum medium (Planch.) Britton
FLAX FAMILY

PLATE 51

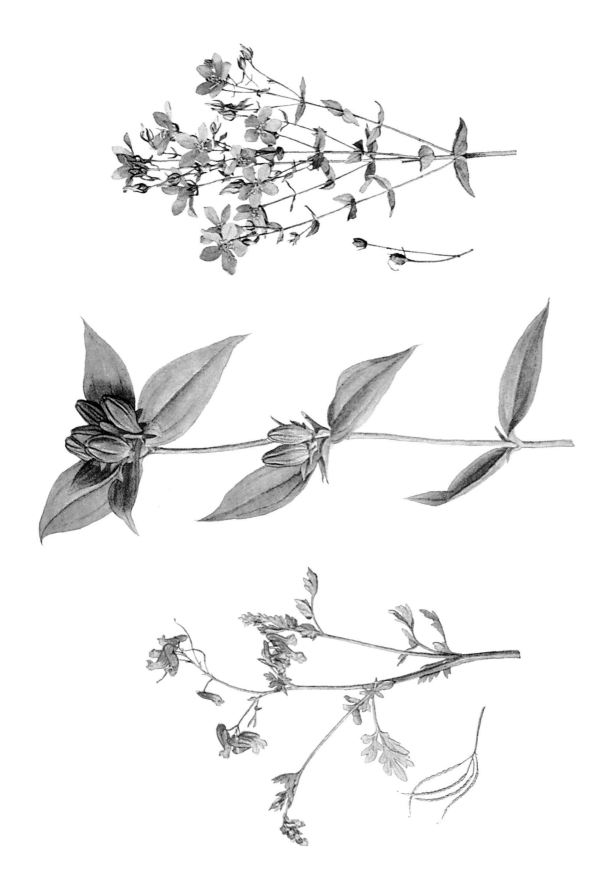

ROSEGENTIAN
Sabatia angularis (L.) Pursh
GENTIAN FAMILY

CLOSED GENTIAN
Gentiana andrewsi Griseb.
GENTIAN FAMILY

PINK CORYDALIS
Capnoides sempervirens (L.) Borck.
FUMITORY FAMILY

PLATE 52

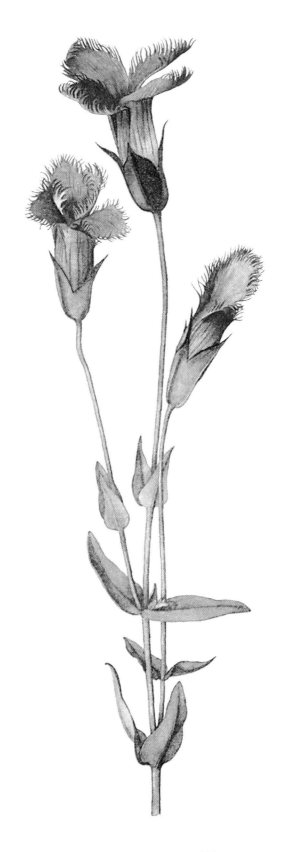

FRINGED GENTIAN
Gentiana crinita Froelich
GENTIAN FAMILY

PLATE 53

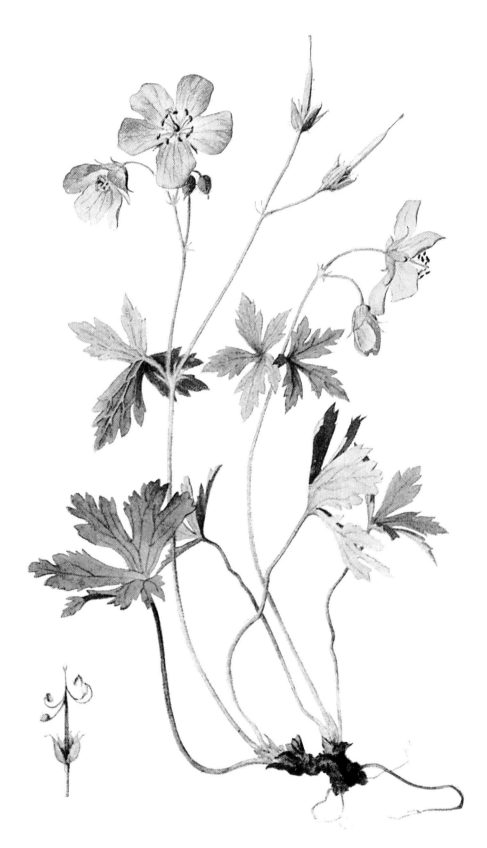

WILD GERANIUM
Geranium maculatum L.
GERANIUM FAMILY

PLATE 54

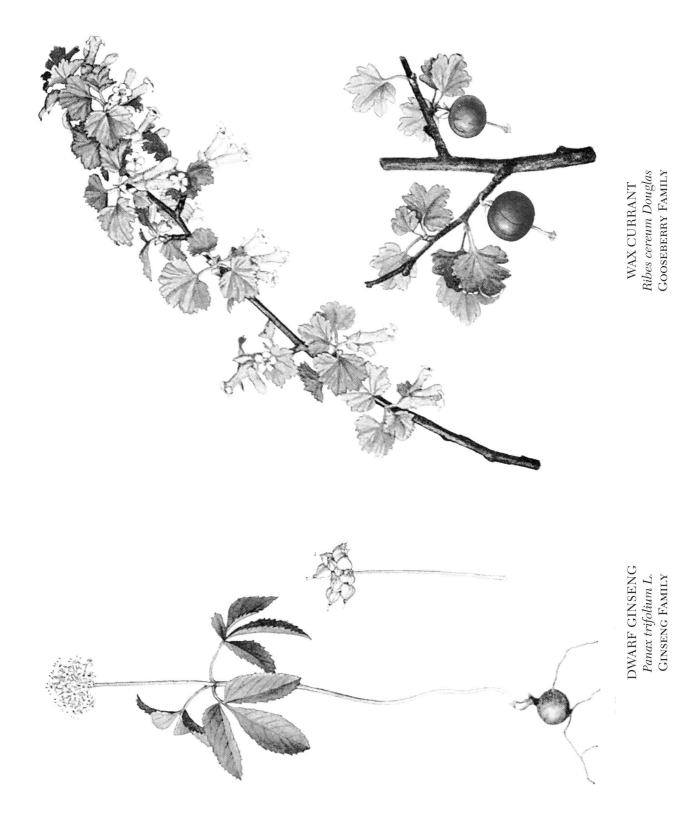

WAX CURRANT
Ribes cereum Douglas
GOOSEBERRY FAMILY

DWARF GINSENG
Panax trifolium L.
GINSENG FAMILY

PLATE 55

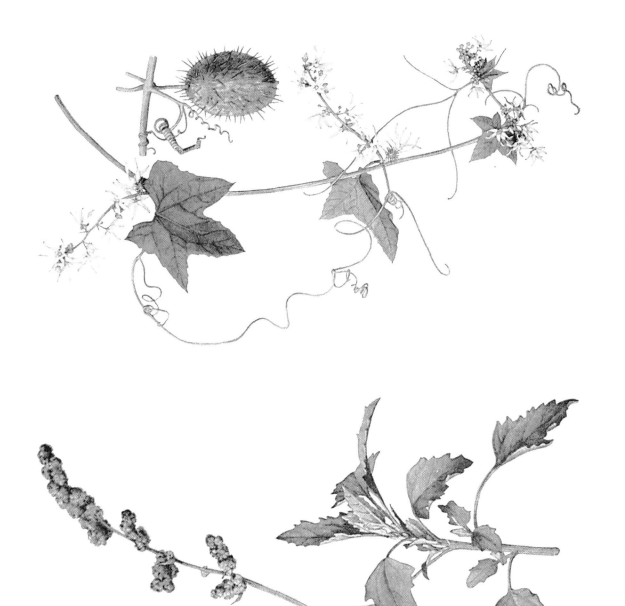

MOCK-CUCUMBER
Echinocystis lobata T. & G.
GOURD FAMILY

LAMBS-QUARTERS
Chenopodium album L.
GOOSEFOOT FAMILY

PLATE 56

VIRGINIA CREEPER
Ampelopsis quinquefolia Michx.
GRAPE FAMILY

PLATE 57

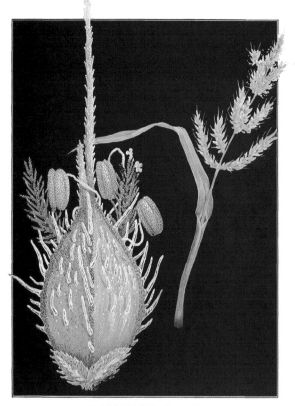

BARNYARD GRASS
Echinochloa crusgalli (L.) Beauv.
GRASS FAMILY

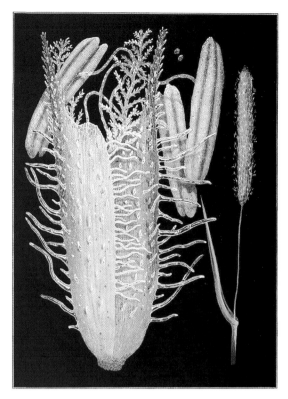

TIMOTHY
Phleum pretense L.
GRASS FAMILY

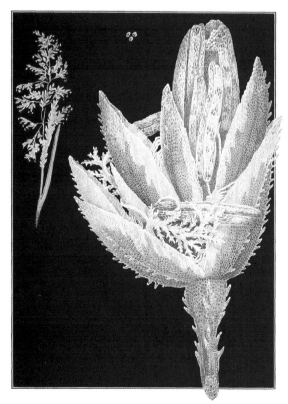

KENTUCKY BLUEGRASS
Poa pratensis L.
GRASS FAMILY

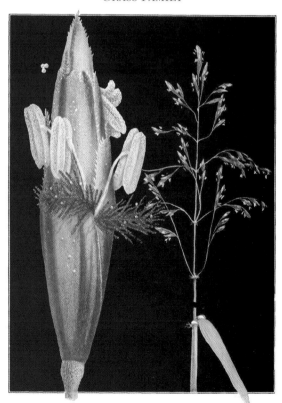

PURPLETOP
Triodia flava (L.) Hitchcock
GRASS FAMILY

PLATE 58

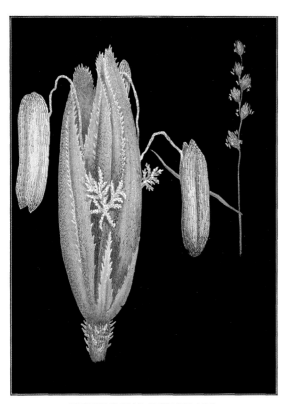

PERENNIAL RYEGRASS
Lolium perenne L.
GRASS FAMILY

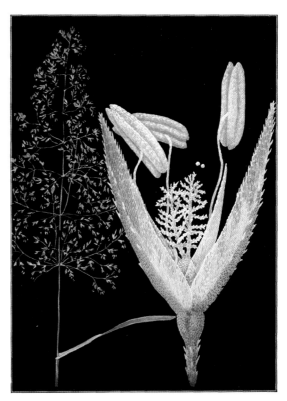

REDTOP
Agrostis palustris Huds.
GRASS FAMILY

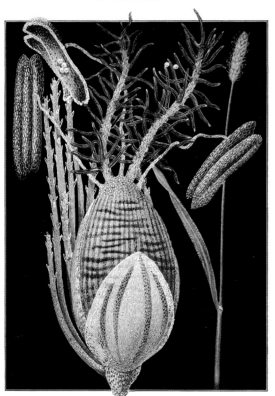

YELLOW FOXTAIL
Chaetochloa lutescens (Weigel) Stuntz
GRASS FAMILY

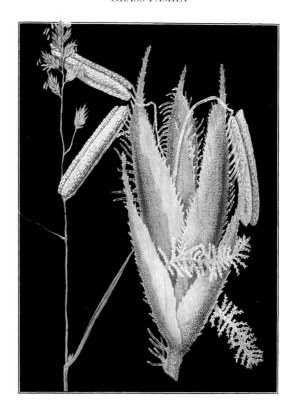

ORCHARD GRASS
Dactylis glomerata L.
GRASS FAMILY

PLATE 59

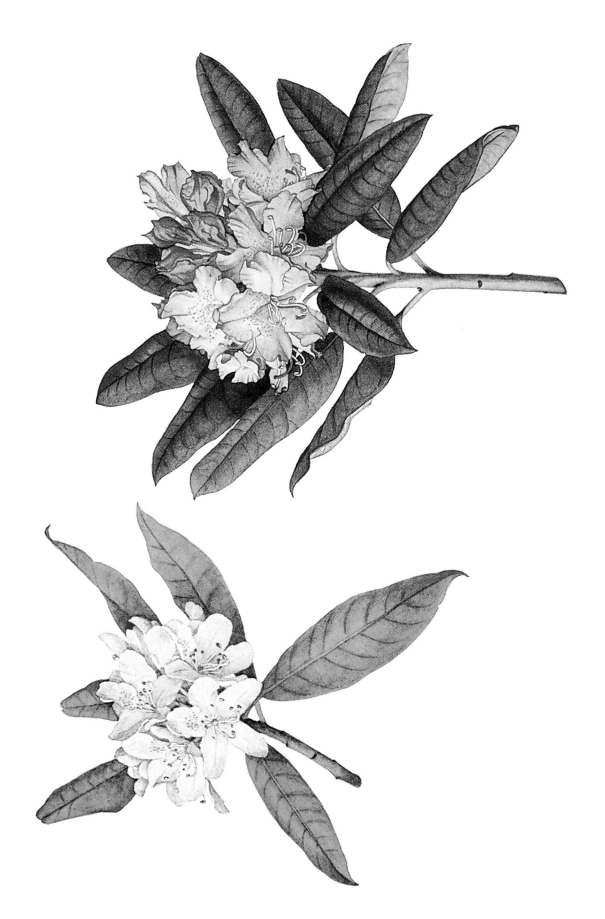

COAST RHODODENDRON
Rhododendron californicum Hooker
HEATH FAMILY
Washington State Flower

ROSEBAY RHODODENDRON
Rhododendron maximum L.
HEATH FAMILY
West Virginia State Flower

PLATE 60

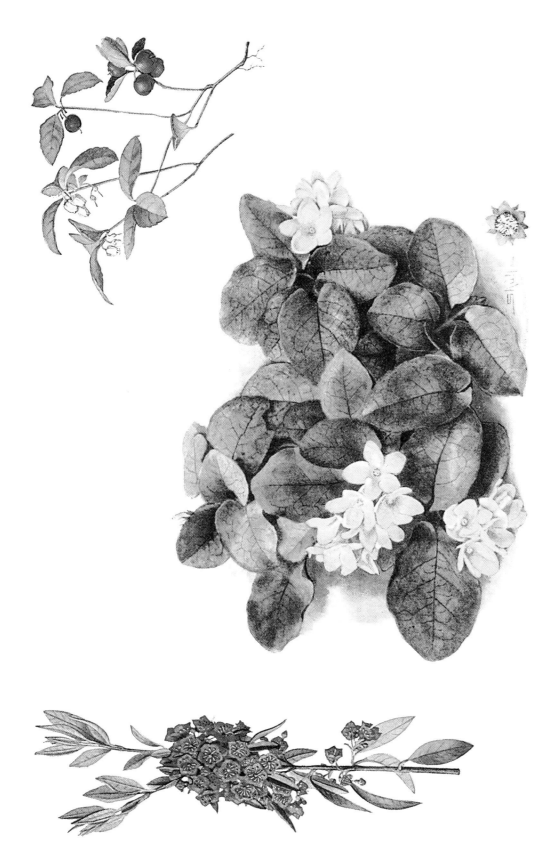

WINTERGREEN
Gaultheria procumbens L.
HEATH FAMILY

TRAILING ARBUTUS
Epigaea repens L.
HEATH FAMILY
Massachusetts State Flower

LAMBKILL
Kalmia angustifolia L.
HEATH FAMILY

PLATE 61

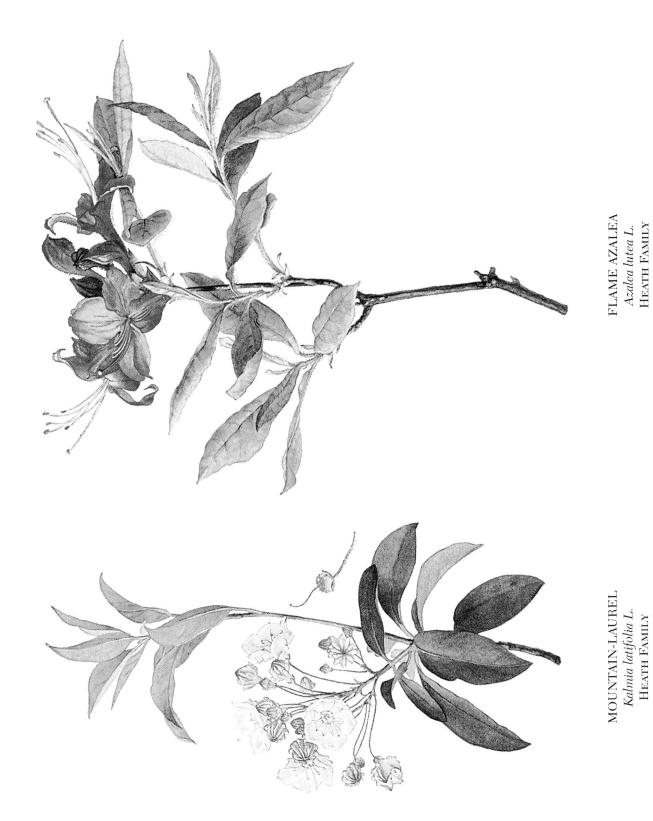

FLAME AZALEA
Azalea lutea L.
HEATH FAMILY

MOUNTAIN-LAUREL
Kalmia latifolia L.
HEATH FAMILY
Connecticut State Flower

PLATE 62

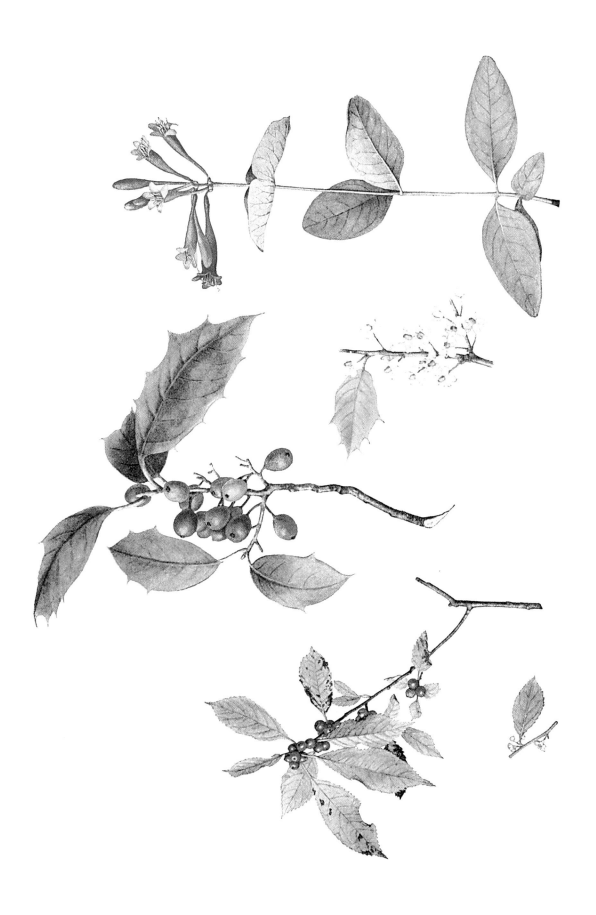

TRUMPET HONEYSUCKLE
Lonicera sempervirens L.
HONEYSUCKLE FAMILY

AMERICAN HOLLY
Ilex opaca Ait.
HOLLY FAMILY

COMMON WINTERBERRY
Ilex verticillata (L.) A. Gray
HOLLY FAMILY

PLATE 63

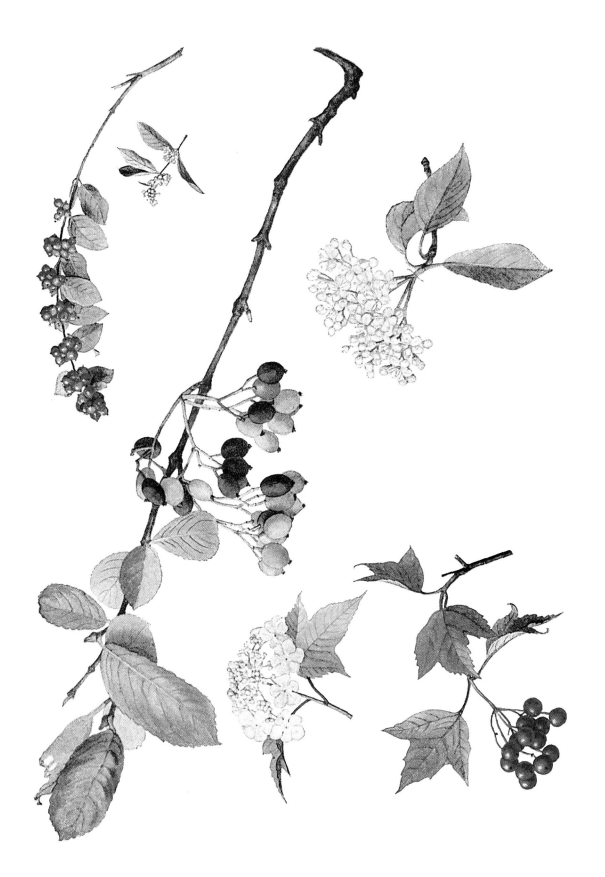

CORALBERRY (Upper right)
Symphoricarpos orbiculatus Moench
HONEYSUCKLE FAMILY

BLACKHAW (Middle and lower right)
Viburnum prunifolium L.
HONEYSUCKLE FAMILY

AMERICAN CRANBERRY BUSH
Viburnum americanum Mill.
HONEYSUCKLE FAMILY

PLATE 64

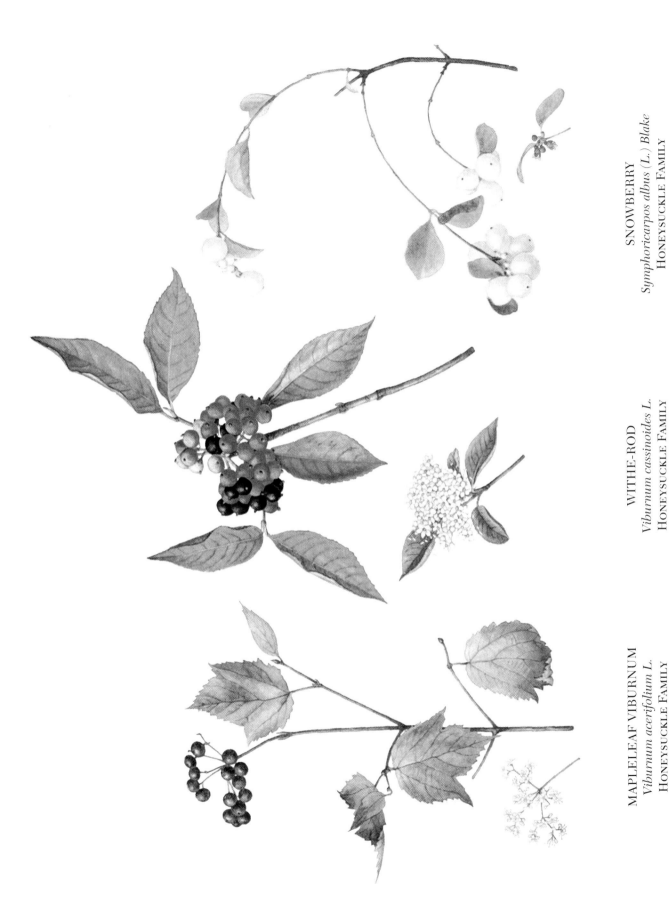

SNOWBERRY
Symphoricarpos albus (L.) Blake
HONEYSUCKLE FAMILY

WITHE-ROD
Viburnum cassinoides L.
HONEYSUCKLE FAMILY

MAPLELEAF VIBURNUM
Viburnum acerifolium L.
HONEYSUCKLE FAMILY

PLATE 65

LEWIS MOCKORANGE
Philadelphus lewisi Pursh
HYDRANGEA FAMILY
Idaho State Flower

AMERICAN ELDER
Sambucus canadensis L.
HONEYSUCKLE FAMILY

PLATE 66

RED PINESAP
Hypopitys insignata Bicknell
INDIANPIPE FAMILY

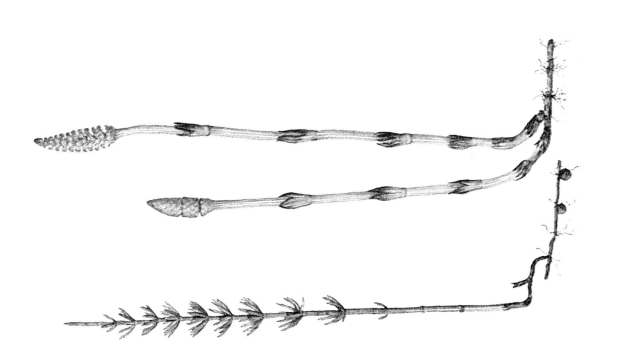

HORSETAIL
Equisetum arvense L.
HORSETAIL FAMILY

PLATE 67

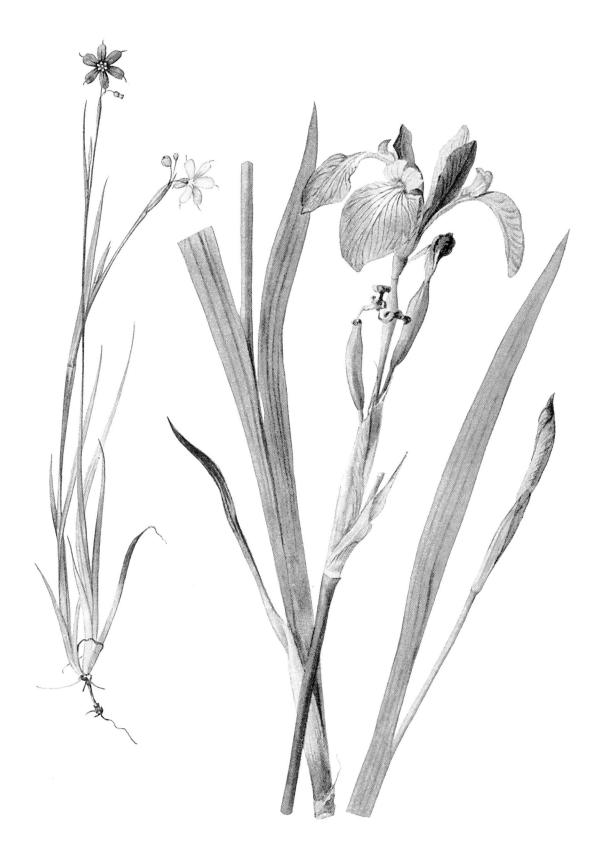

EASTERN BLUE-EYED GRASS
Sisyrinchium graminoides Bicknell
Iris Family

BLUEFLAG IRIS
Iris versicolor L.
Iris Family

PLATE 68

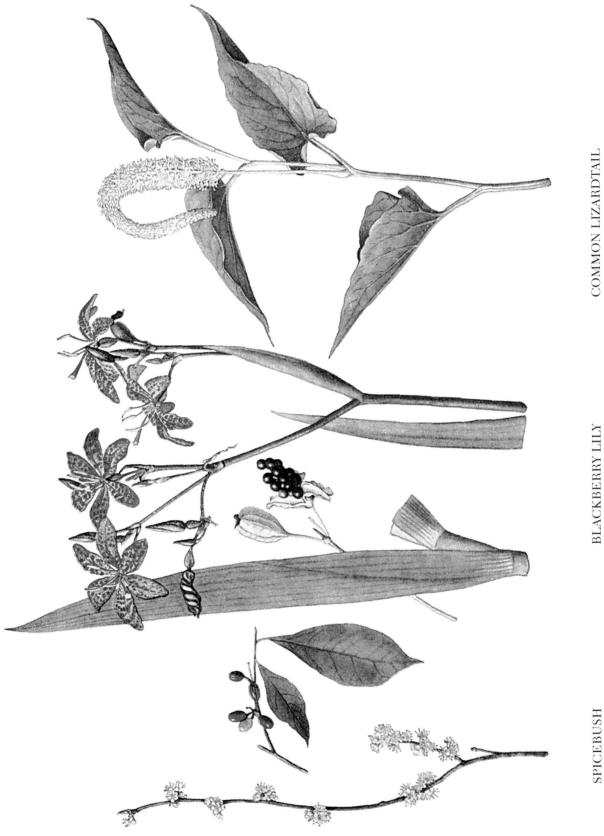

COMMON LIZARDTAIL
Saururus cernuus L.
LIZARDTAIL FAMILY

BLACKBERRY LILY
Belamcanda chinensis (L.) DC.
IRIS FAMILY

SPICEBUSH
Benzoin aestivale (L.) Nees
LAUREL FAMILY

PLATE 69

GRAYS LILY
Lilium grayi S. Wats.
LILY FAMILY

FIELD GARLIC
Allium vineale L.
LILY FAMILY

TAWNY DAYLILY
Hemerocallis fulva L.
LILY FAMILY

PLATE 70

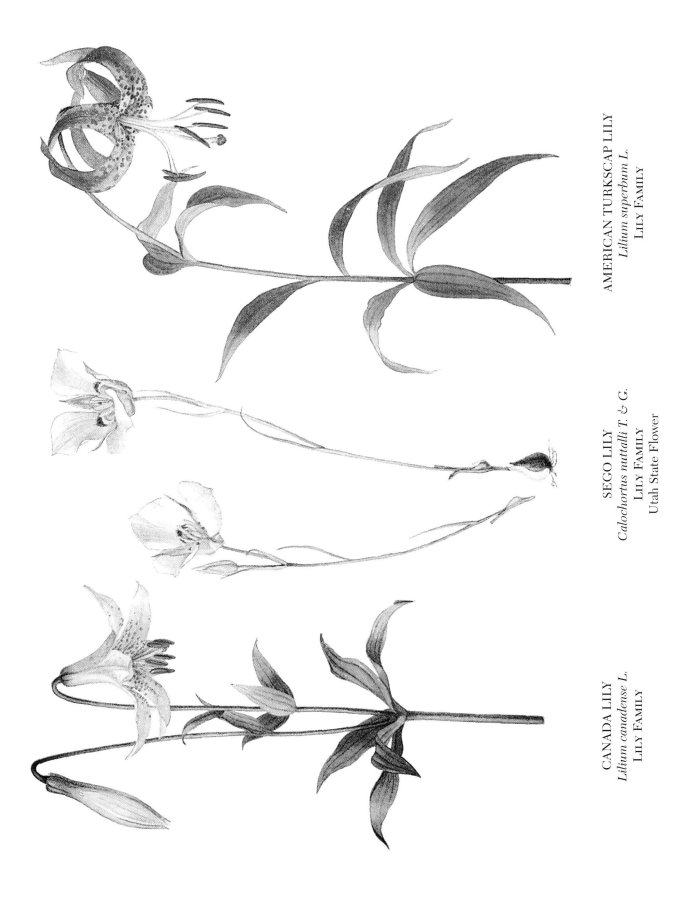

AMERICAN TURKSCAP LILY
Lilium superbum L.
LILY FAMILY

SEGO LILY
Calochortus nuttalli T. & G.
LILY FAMILY
Utah State Flower

CANADA LILY
Lilium canadense L.
LILY FAMILY

PLATE 71

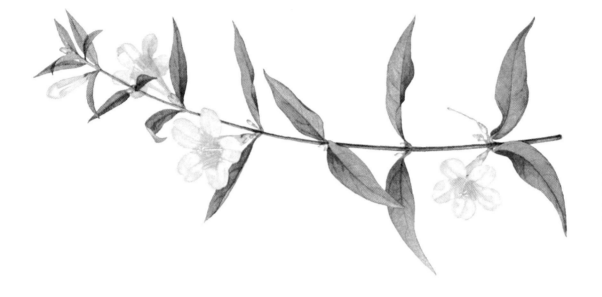

CAROLINA JESSAMINE
Gelsemium sempervirens (L.) Ait. f.
LOGANIA FAMILY
South Carolina State Flower

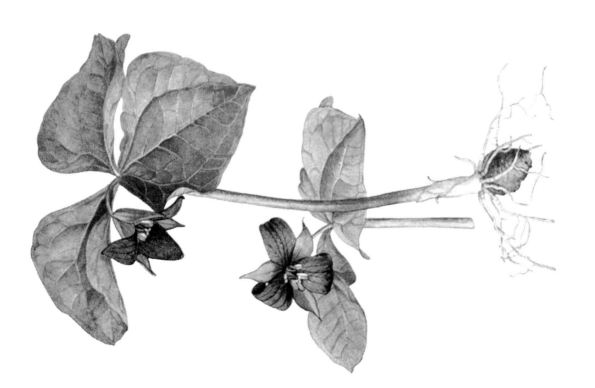

PURPLE TRILLIUM
Trillium erectum L.
LILY-OF-THE-VALLEY FAMILY

PLATE 72

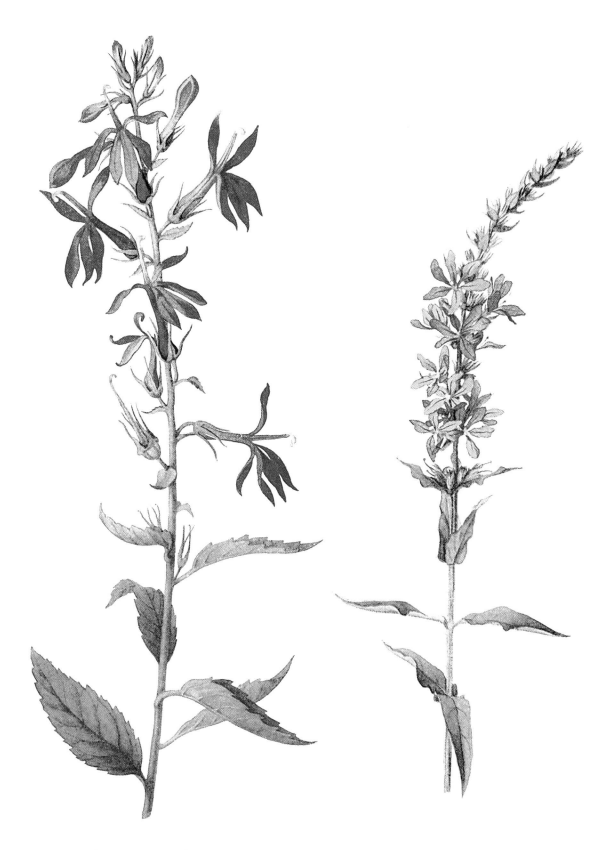

CARDINAL FLOWER
Lobelia cardinalis L.
Lobelia Family

PURPLE LOOSESTRIFE
Lythrum salicaria L.
Loosestrife Family

PLATE 73

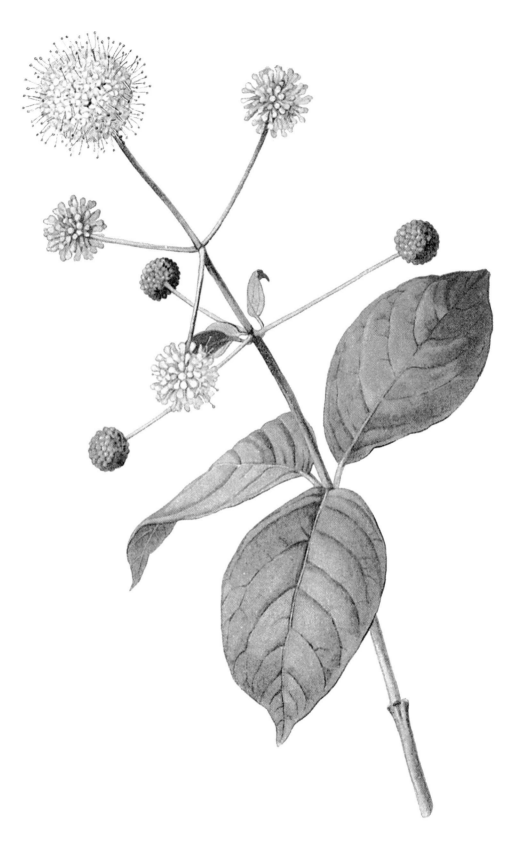

COMMON BUTTONBUSH
Cephalanthus occidentalis L.
MADDER FAMILY

PLATE 74

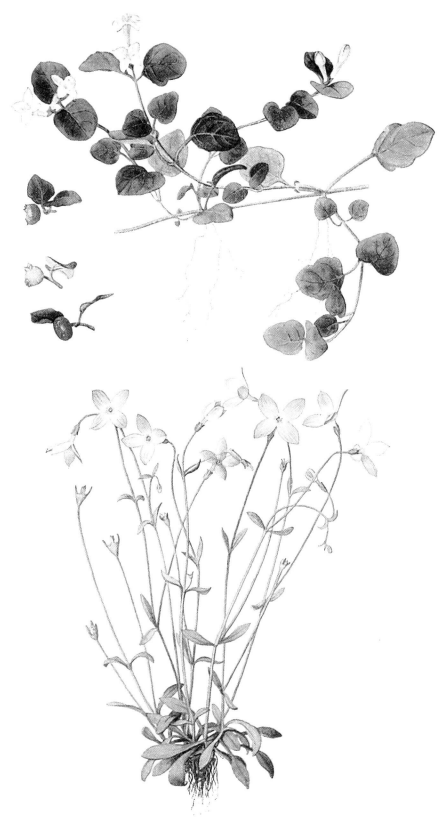

PARTRIDGEBERRY (Upper)
Mitchella repens L.
MADDER FAMILY

BLUETS (Lower)
Houstonia caerulea L.
MADDER FAMILY

PLATE 75

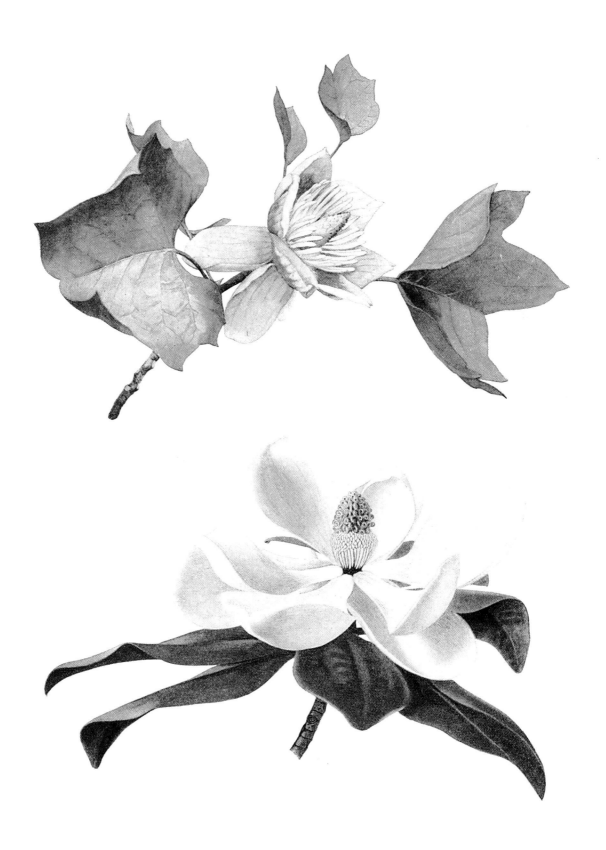

TULIPTREE (Upper)
Liriodendron tulipifera L.
Magnolia Family
Indiana State Flower

SOUTHERN MAGNOLIA (Lower)
Magnolia grandiflora L.
Magnolia Family
Louisiana and Mississippi State Flower

PLATE 76

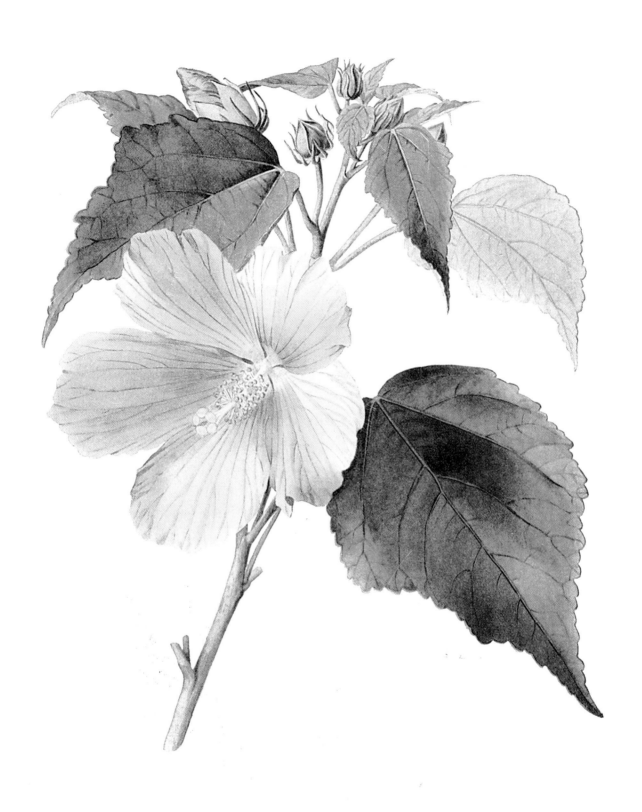

COMMON ROSEMALLOW
Hibiscus moscheutos L.
MALLOW FAMILY

PLATE 77

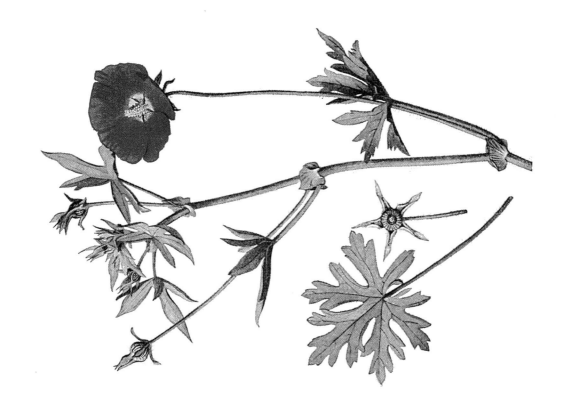

LOW POPPY-MALLOW
Callirhoe involucrata (T. & G.) A. Gray
MALLOW FAMILY

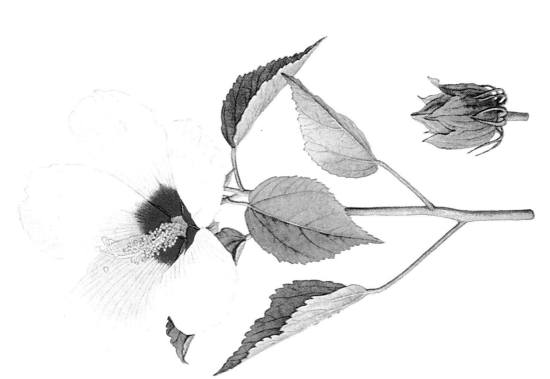

CRIMSON-EYE ROSEMALLOW
Hibiscus oculiroseus Britton
MALLOW FAMILY

PLATE 78

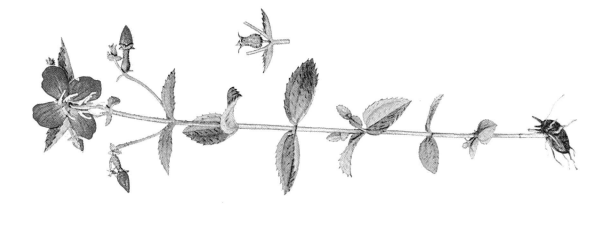

COMMON MEADOW BEAUTY
Rhexia virginica L.
MEADOWBEAUTY FAMILY

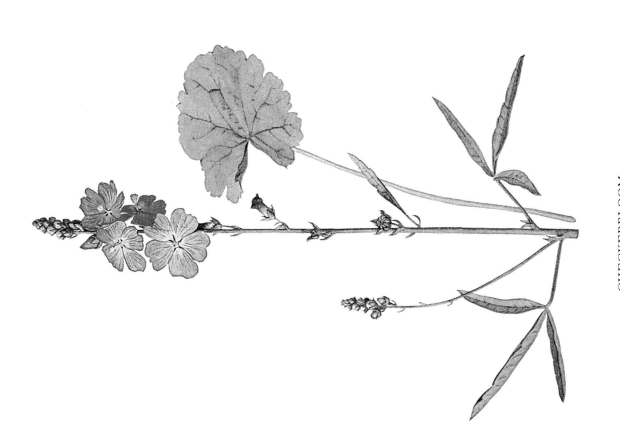

CHECKERBLOOM
Sidalcea malvaeflora (Moc. & Sesse) A. Gray
MALLOW FAMILY

PLATE 79

COMMON MILKWEED
Asclepias syriaca L.
MILKWEED FAMILY

BLACK SWALLOW-WORT
Cynanchum nigrum (L.) Pers.
MILKWEED FAMILY

FOURLEAF MILKWEED
Asclepias quadrifolia Jacq.
MILKWEED FAMILY

PLATE 80

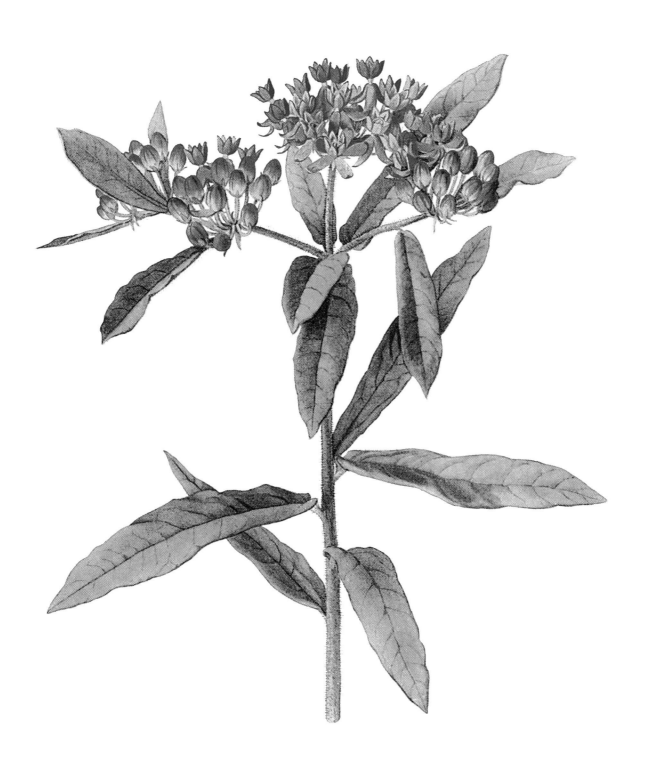

BUTTERFLYWEED
Asclepias tuberosa L.
MILKWEED FAMILY

PLATE 81

HAIRY WILD BERGAMOT
Monarda mollis L.
MINT FAMILY

HYSSOP SKULLCAP
Scutellaria integrifolia L.
MINT FAMILY

GROUND-IVY
Glecoma hederacea L.
MINT FAMILY

PURPLE WILD BERGAMOT
Monarda media Willd.
MINT FAMILY

PLATE 82

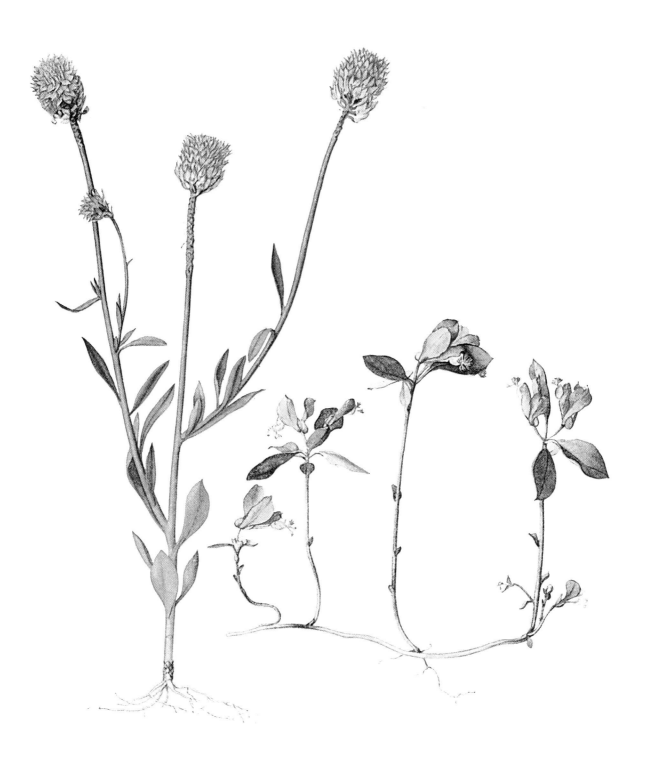

ORANGE POLYGALA
Polygala lutea L.
MILKWORT FAMILY

FRINGED POLYGALA
Polygala paucifolia Willd.
MILKWORT FAMILY

PLATE 83

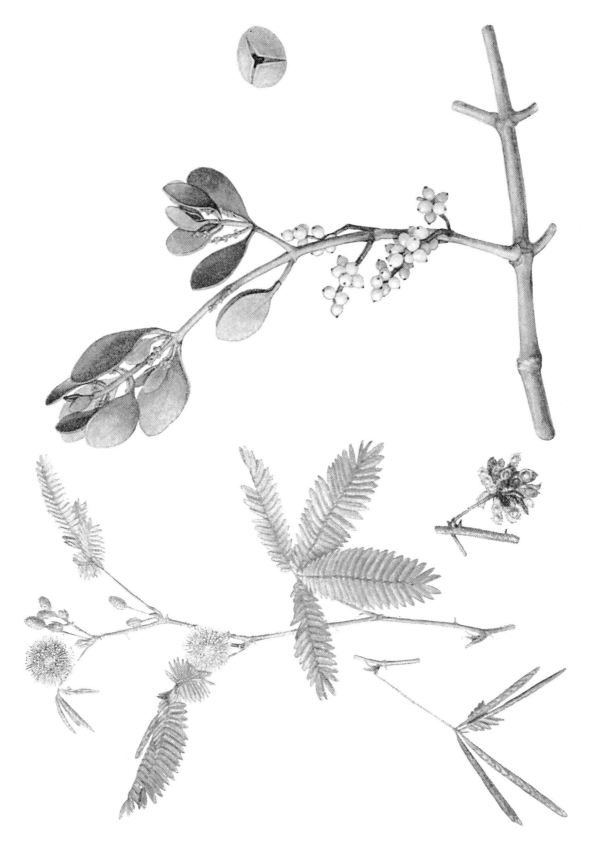

AMERICAN MISTLETOE
Phoradendron flavescens (Pursh) Nutt.
MISTLETOE FAMILY
Oklahoma State Flower

SENSITIVE PLANT
Mimosa pudica L.
MIMOSA FAMILY

PLATE 84

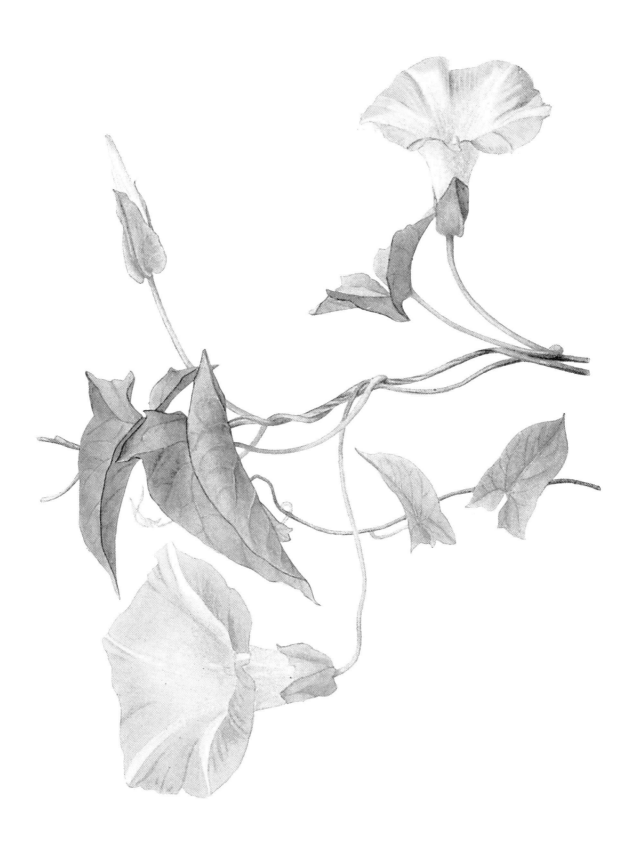

HEDGE BINDWEED
Convolvulus sepium L.
MORNING-GLORY FAMILY

PLATE 85

CHARLOCK
Brassica arvensis (L.) Ktze.
MUSTARD FAMILY

COMMON MOONSEED
Menispermum canadense L.
MOONSEED FAMILY

FIELD BINDWEED
Convolvulus arvensis L.
MORNING-GLORY FAMILY

PLATE 86

CLAMMY GROUNDCHERRY
Physalis heterophylla Nees.
NIGHTSHADE FAMILY

COMMON HOP
Humulus lupulus L.
NETTLE FAMILY

PLATE 87

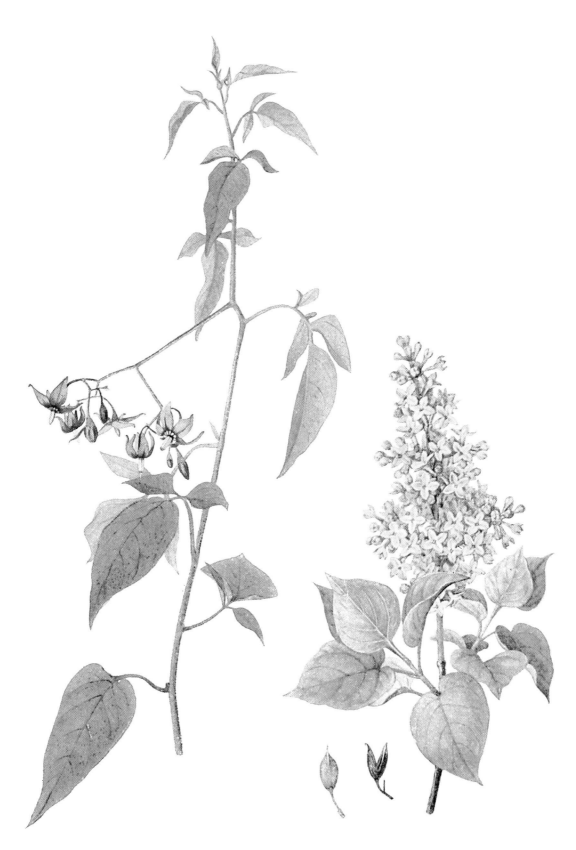

BITTER NIGHTSHADE
Solanum dulcamara L.
NIGHTSHADE FAMILY

COMMON LILAC
Syringa vulgaris L.
OLIVE FAMILY
New Hampshire State Flower

PLATE 88

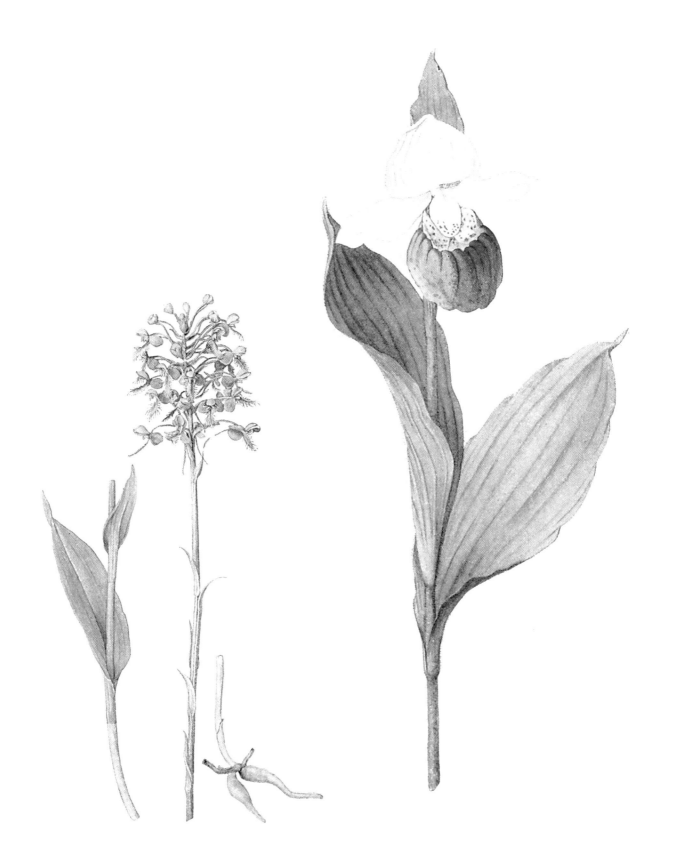

YELLOW-FRINGED ORCHID
Habanaria ciliaris (L.) R. Br.
ORCHIS FAMILY

SHOWY LADY'S SLIPPER
Cypripedium reginae Walt.
ORCHIS FAMILY
Minnesota State Flower

PLATE 89

ARETHUSA
Arethusa bulbosa L.
ORCHIS FAMILY

SMALL YELLOW LADY'S SLIPPER
Cypripedium parviflorum Salisb.
ORCHIS FAMILY

ROSE POGONIA
Pogonia ophioglossoides (L.) Ker
ORCHIS FAMILY

PLATE 90

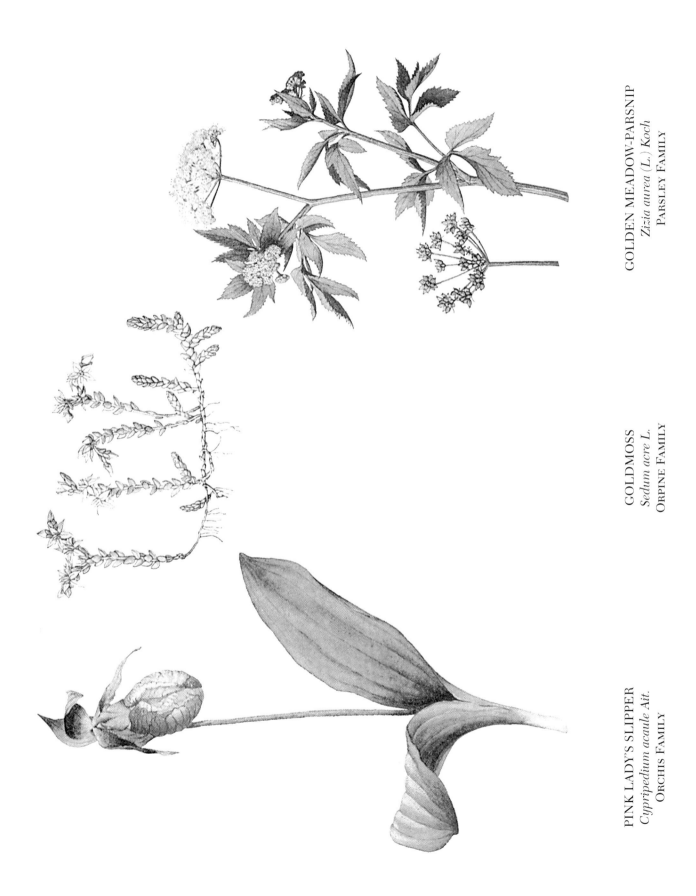

GOLDEN MEADOW-PARSNIP
Zizia aurea (L.) Koch
PARSLEY FAMILY

GOLDMOSS
Sedum acre L.
ORPINE FAMILY

PINK LADY'S SLIPPER
Cypripedium acaule Ait.
ORCHIS FAMILY

PLATE 91

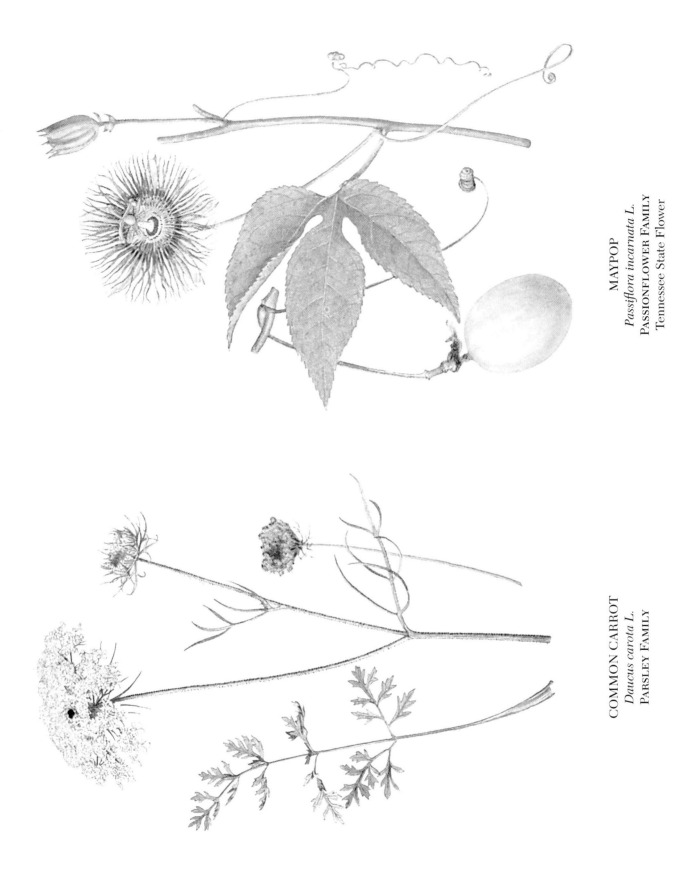

MAYPOP
Passiflora incarnata L.
PASSIONFLOWER FAMILY
Tennessee State Flower

COMMON CARROT
Daucus carota L.
PARSLEY FAMILY

PLATE 92

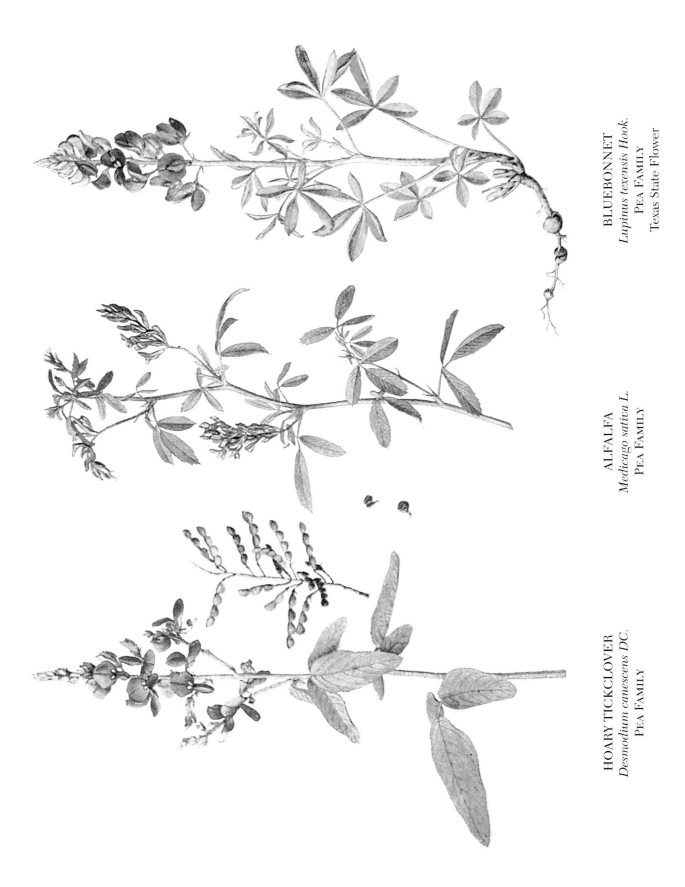

BLUEBONNET
Lupinus texensis Hook.
PEA FAMILY
Texas State Flower

ALFALFA
Medicago sativa L.
PEA FAMILY

HOARY TICKCLOVER
Desmodium canescens DC.
PEA FAMILY

PLATE 93

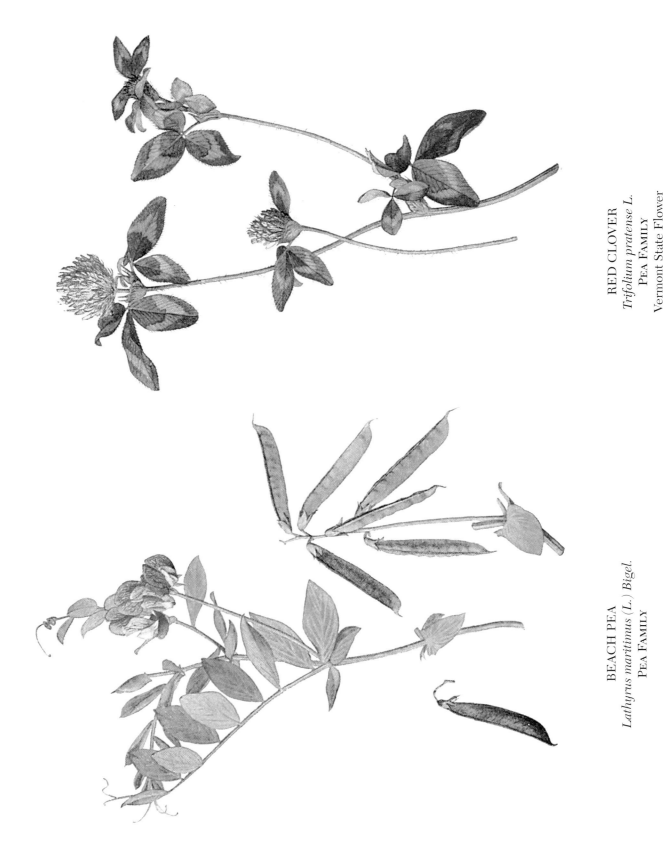

RED CLOVER
Trifolium pratense L.
PEA FAMILY
Vermont State Flower

BEACH PEA
Lathyrus maritimus (L.) Bigel.
PEA FAMILY

PLATE 94

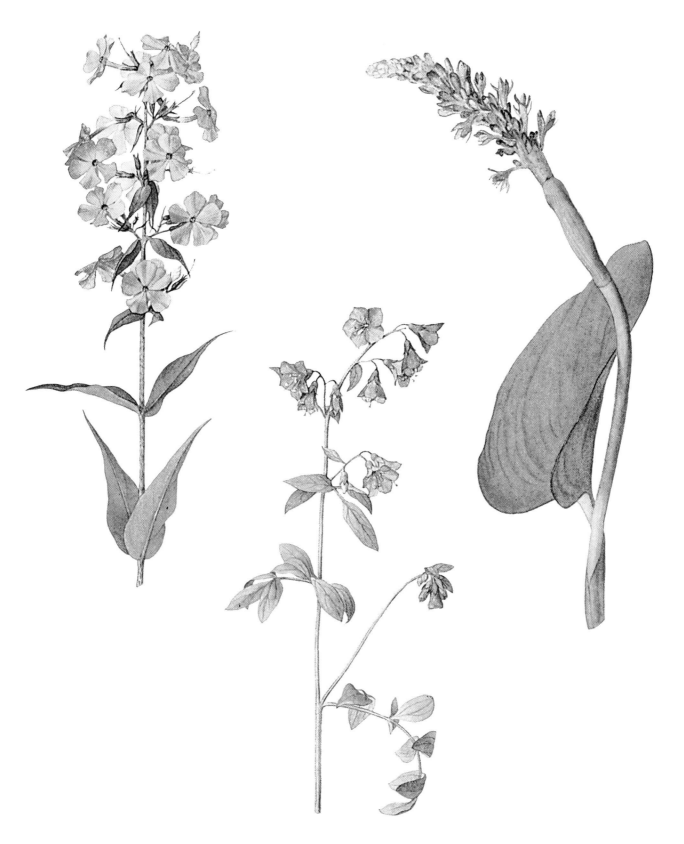

SWEET-WILLIAM PHLOX
Phlox maculata L.
PHLOX FAMILY

CREEPING POLEMONIUM
Polemonium reptans L.
PHLOX FAMILY

PICKERELWEED
Pontederia cordata L.
PICKERELWEED FAMILY

PLATE 95

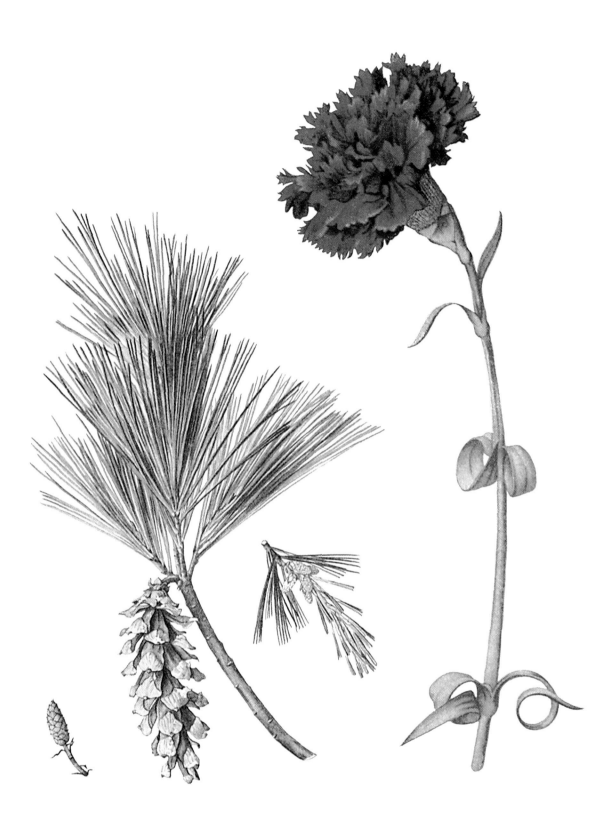

WHITE PINE
Pinus strobus L.
PINE FAMILY
Maine State Flower

RED CARNATION
Dianthus caryophyllus L.
PINK FAMILY
Ohio State Flower

PLATE 96

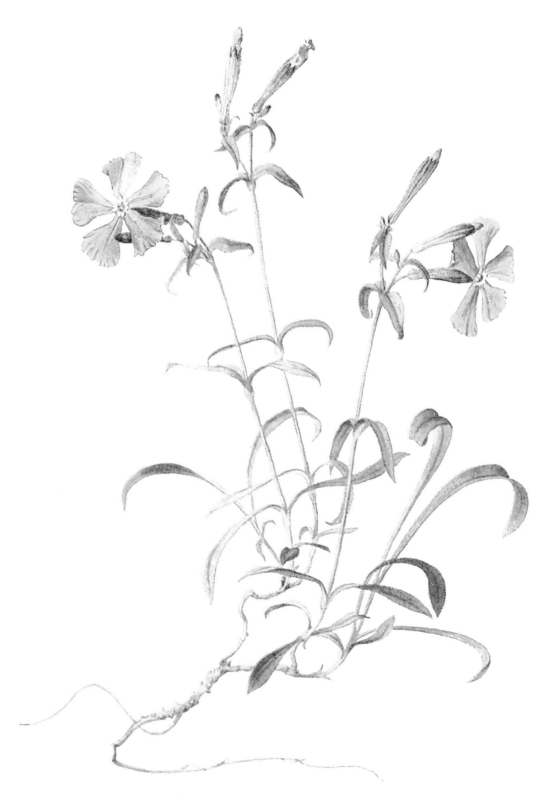

PEATPINK
Silene caroliniana Walt.
PINK FAMILY

PLATE 97

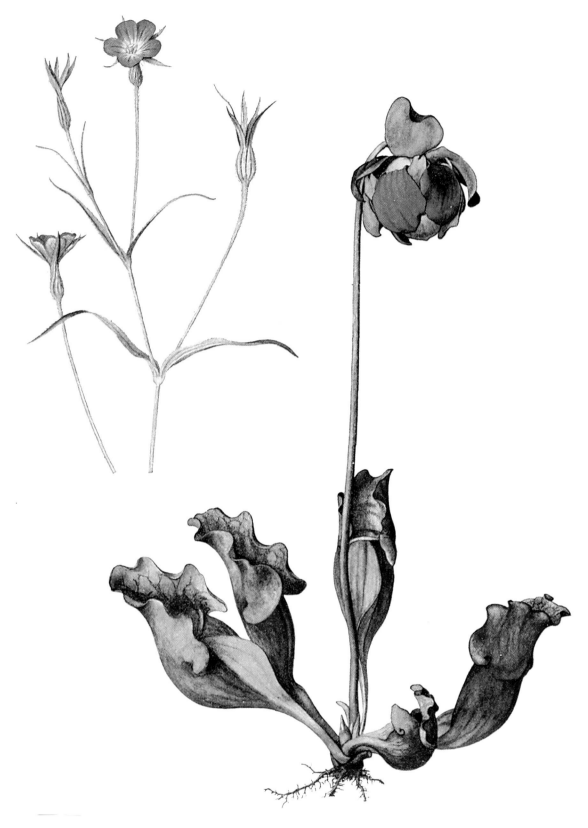

CORNCOCKLE
Agrostemma githago L.
PINK FAMILY

COMMON PITCHERPLANT
Sarracenia purpurea L.
PITCHERPLANT FAMILY

PLATE 98

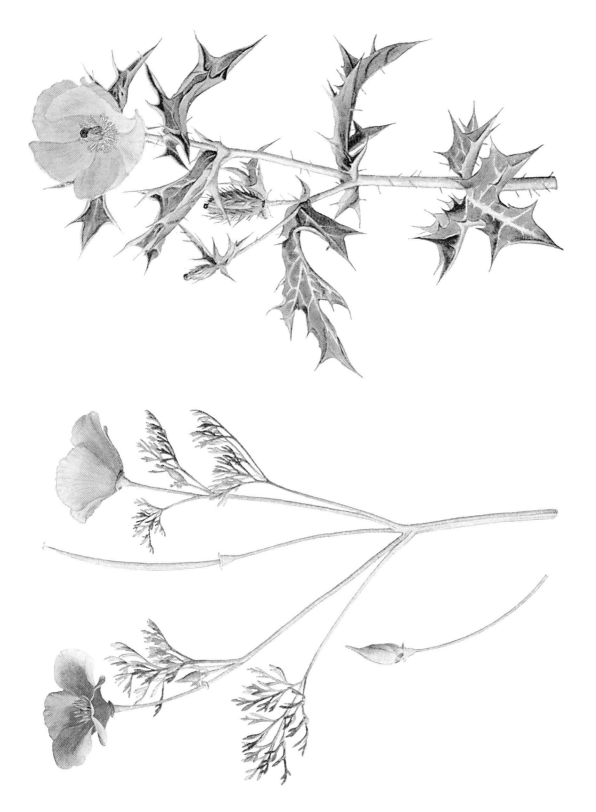

MEXICAN PRICKLEPOPPY
Argemone Mexicana L.
POPPY FAMILY

COMMON CALIFORNIA POPPY
Eschscholtzia californica Cham.
POPPY FAMILY
California State Flower

PLATE 101

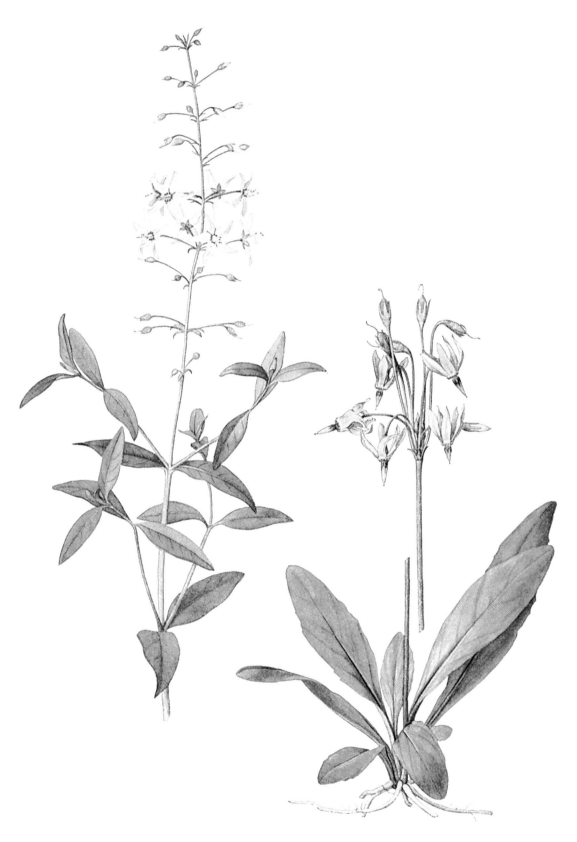

SWAMPCANDLE
Lysimachia terrestris (L.) B. S. P.
PRIMROSE FAMILY

COMMON SHOOTINGSTAR
Dodecatheon meadia L.
PRIMROSE FAMILY

PLATE 102

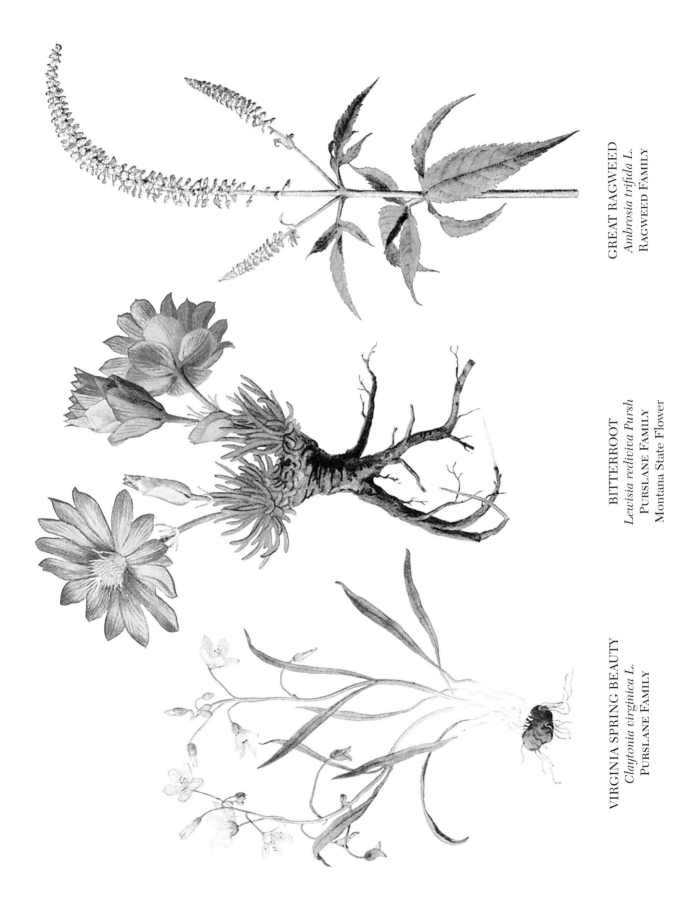

GREAT RAGWEED
Ambrosia trifida L.
RAGWEED FAMILY

BITTERROOT
Lewisia rediviva Pursh
PURSLANE FAMILY
Montana State Flower

VIRGINIA SPRING BEAUTY
Claytonia virginica L.
PURSLANE FAMILY

PLATE 103

FLOWERING RASPBERRY
Rubus odoratus L.
ROSE FAMILY

PLATE 104

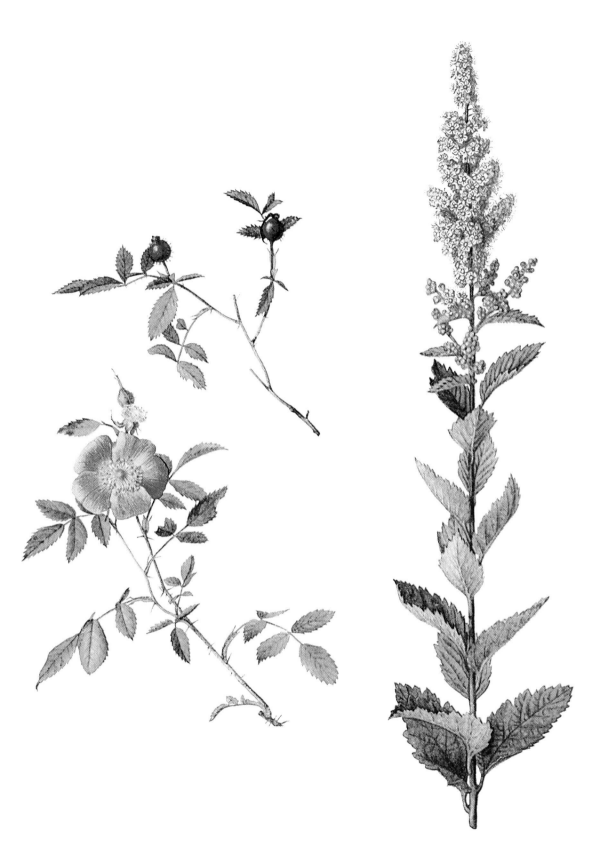

PASTURE ROSE
Rosa carolina L. (Rosa humilis Marsh.)
ROSE FAMILY
Iowa, North Dakota, Georgia, and New York State Flower

HARDHACK
Spiraea tomentosa L.
ROSE FAMILY

PLATE 105

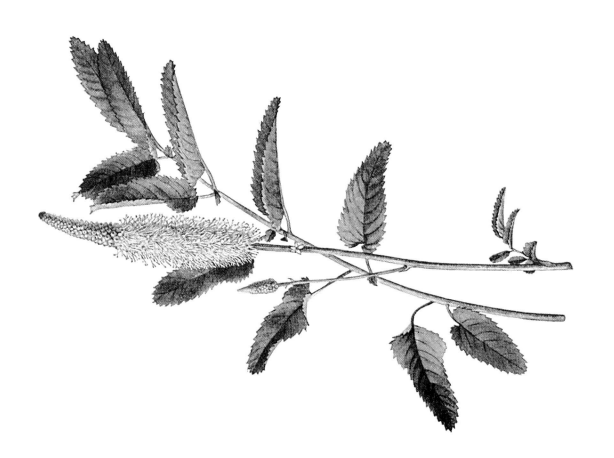

VIRGINIA STRAWBERRY
Fragaria virginiana Duchesne
ROSE FAMILY

AMERICAN BURNET
Sanguisorba canadensis L.
ROSE FAMILY

PLATE 106

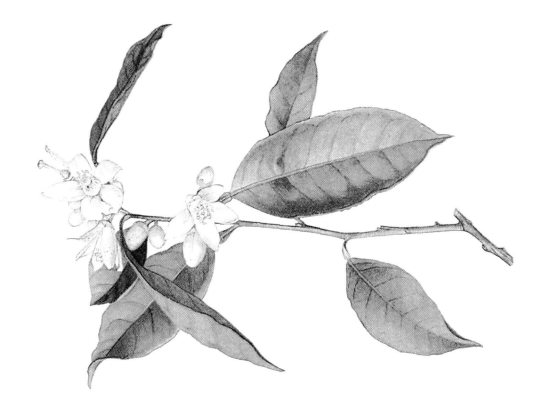

ORANGE BLOSSOM
Citrus sinensis Osbeck
RUE FAMILY
Florida State Flower

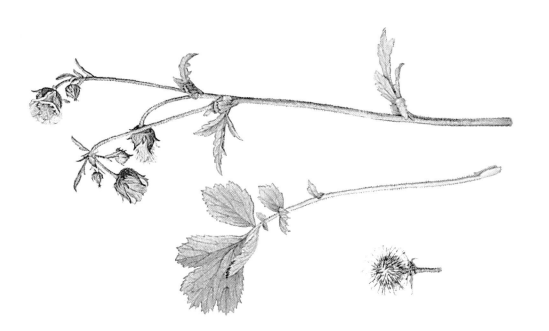

PURPLE AVENS
Geum rivale L.
ROSE FAMILY

PLATE 107

GOLDEN ST. JOHN'S WORT
Hypericum aureum Bartr.
ST. JOHNSWORT FAMILY

COMMON ST. JOHN'S WORT
Hypericum perforatum L.
ST. JOHNSWORT FAMILY

COMMON WOODRUSH
Juncoides campestre (L.) Ktze.
RUSH FAMILY

PLATE 108

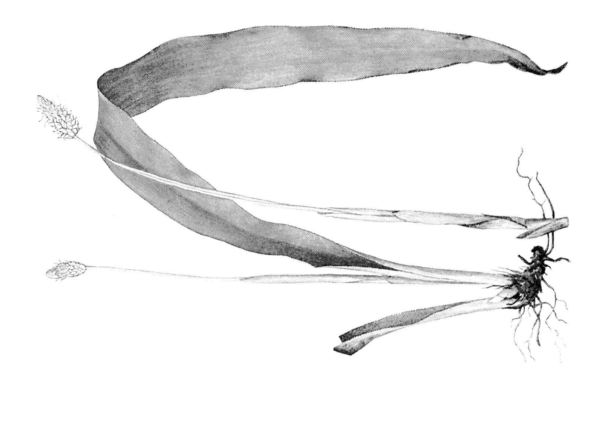

FRASER SEDGE
Carex fraseri Andr.
SEDGE FAMILY

CORALBELLS
Heuchera sanguinea Engelm.
SAXIFRAGE FAMILY

PLATE 109

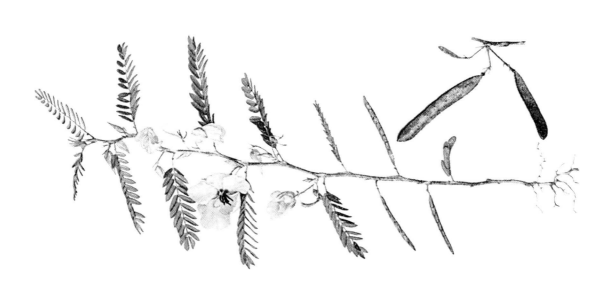

CARRIONFLOWER
Smilax herbacea L.
SMILAX FAMILY

PARTRIDGE PEA
Chamaecrista fasciculata (Michx.) Greene
SENNA FAMILY

PLATE 110

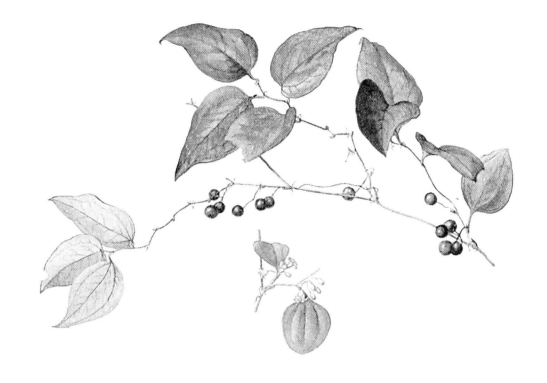

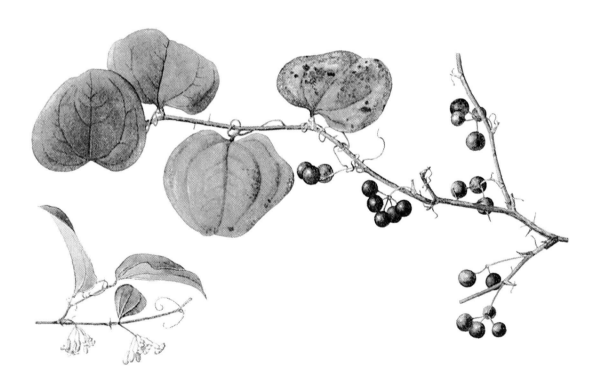

BLUELEAF GREENBRIER (Upper) ROUNDLEAF GREENBRIER (Lower)
Smilax glauca Walt. *Smilax rotundifolia L.*
SMILAX FAMILY SMILAX FAMILY

PLATE 111

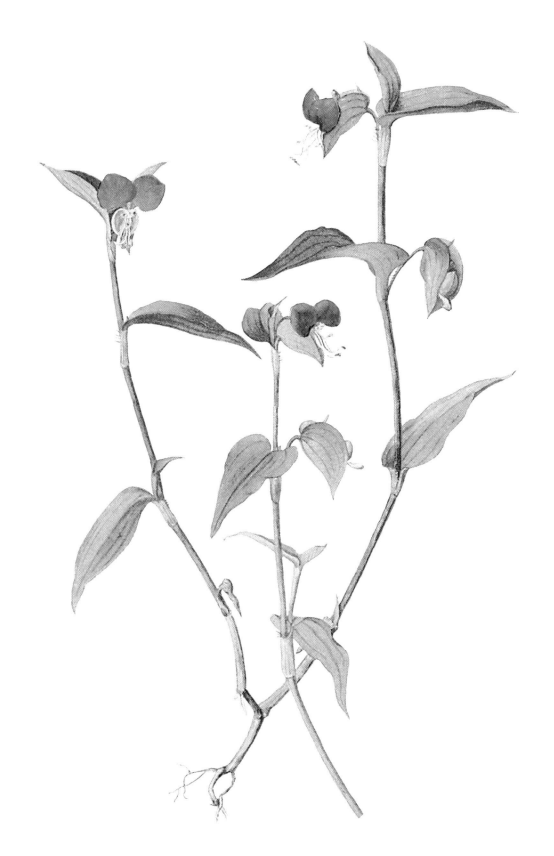

COMMON DAYFLOWER
Commelina communis L.
Spiderwort Family

PLATE 112

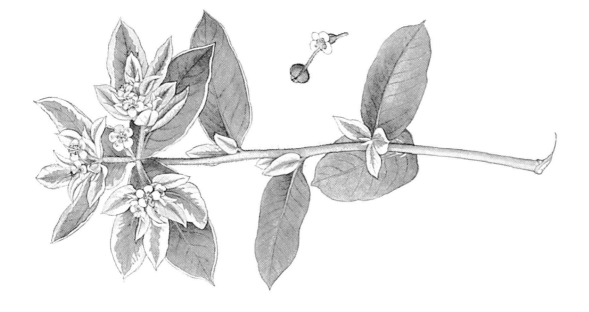

SNOW-ON-THE-MOUNTAIN
Euphorbia marginata Pursh
SPURGE FAMILY

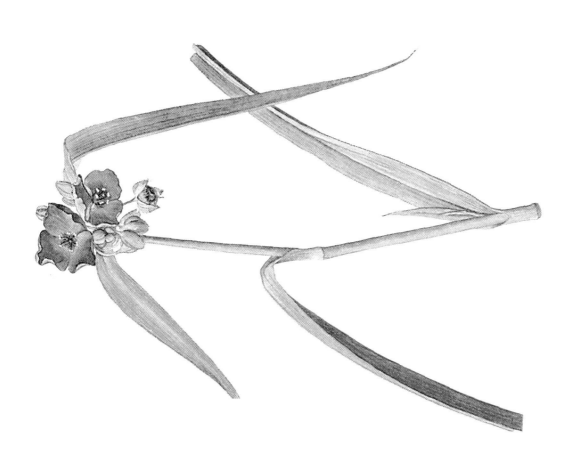

VIRGINIA SPIDERWORT
Tradescantia virginiana L.
SPIDERWORT FAMILY

PLATE 113

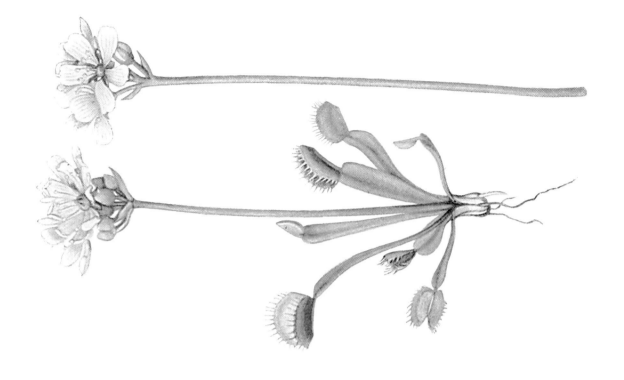

VENUS FLYTRAP
Dionaea muscipula Ellis
SUNDEW FAMILY

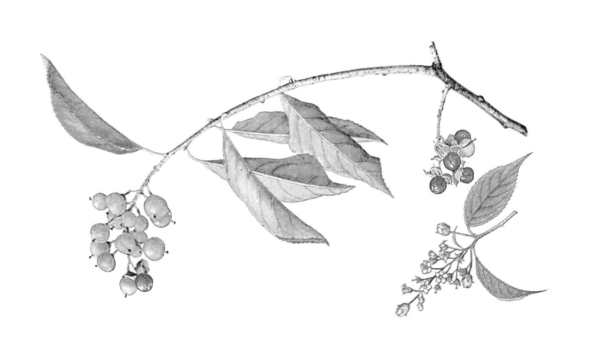

AMERICAN BITTERSWEET
Celastrus scandens L.
STAFFTREE FAMILY

PLATE 114

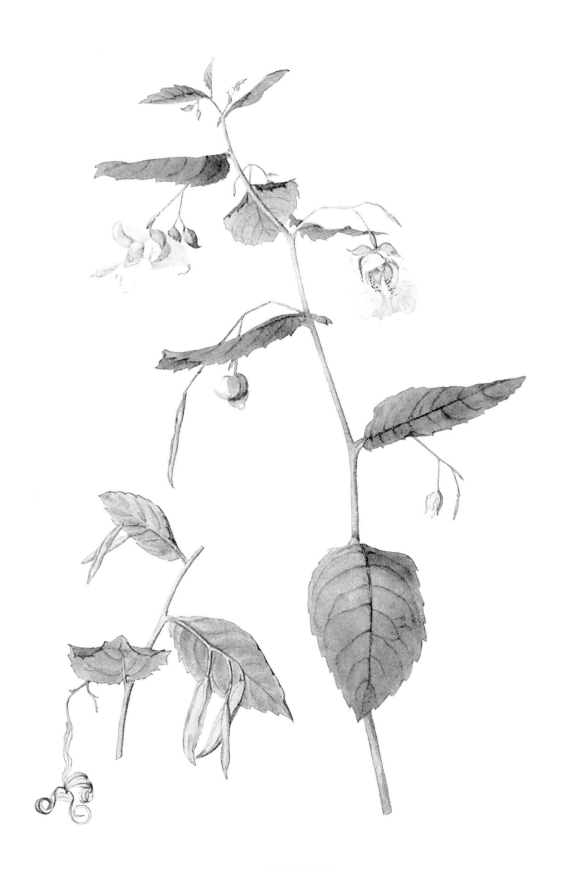

PALE SNAPWEED
Impatiens pallida Nutt.
Touch-me-not Family

PLATE 115

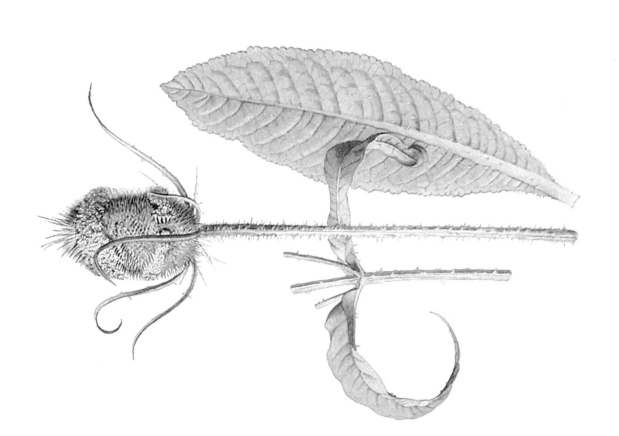

COMMON VALERIAN
Valeriana officinalis L.
VALERIAN FAMILY

TEASEL
Dipsacus sylvestris Huds.
TEASEL FAMILY

PLATE 116